Images of Modern America

ELMWOOD PARK ZOO

Images of Modern America

ELMWOOD PARK ZOO

STAN HUSKEY
FOREWORD BY JERRY SPINELLI

ARCADIA
PUBLISHING

Printed in the United States of America

Library of Congress Control Number: 2015953043

For all general information, please contact Arcadia Publishing:
Telephone 843-853-2070
Fax 843-853-0044
E-mail sales@arcadiapublishing.com
For customer service and orders:
Toll-Free 1-888-313-2665

Visit us on the Internet at www.arcadiapublishing.com

This book is dedicated to my wife, Sue, and daughter, Emily, who put up with me while I spent numerous hours digging through photographs and doing research. I could not have completed this book without their support. It is also for the people who came through with photographs and anecdotes, all of which made this book possible.

CONTENTS

ACKNOWLEDGMENTS

A special thank you goes out to zoo for providing the lion's share of the photographs (and yes, pun intended); Gene Walsh, chief photographer for the *Times Herald* in Norristown for providing some of the more recent photographs at the zoo; Paul Piantone, who, after some digging, came up with a couple of photo albums that made the Morton "Bubby" Weiss chapter a reality; and a special acknowledgement to Susan Owad, who found the only photograph of the lions that once called the zoo home. And to Shaun Rogers, marketing director at Elmwood Park Zoo, for his assistance with gathering photographs and editing captions.

FOREWORD

I was barely a year old when, in 1942, my mother held me up to the camera by the fenced-off gully that ran from the boulevard to Stony Creek past the old Boy Scout cabin. The zoo has been in my life ever since.

When I craved entertainment as a grade-schooler, I could always find it behind the bars at the monkey cages. In high school, employed there for the summer, I painted them (the bars, not the monkeys).

On another day I was painting the bars of the lion's cage. The lion was inside the building, with a lowered hatch between her and me. The third creature on the scene was Art Herr. Art, a former Norristown High basketball coach, had been my biology teacher. In the summer he helped manage the zoo. He was also, as I was about to learn, a practical joker. I looked up from my paintbrush to see him outside the cage, grinning at me. Something told me I should look behind. I did. The protective hatch had been raised, just enough so I could see the lion's head on the other side. So far as I know, that paint job remains unfinished to this day.

Monkey Hill is gone now. It used to plunge from the high school tennis courts, curving past the monkeys and onto the flats of the stony parking lot. One summer in junior high, I resolved to find out how fast my cream-and-green whitewall-tired Roadmaster bike could go. I pedaled ferociously down Monkey Hill, daring a glance at the speedometer: 45 miles per hour. I thought I was flying.

Another summer, in college, I wrote for a new paper in town, the *Montgomery Post*. Since the editor was from Hatboro or some such, I was the go-to guy for features of vintage Norristown. One of my first assignments led me to the historical society, where I researched a signature event that had happened in 1933—a flood that raged through the zoo and swept away aquatic animals, including alligators. They were later retrieved from the basement of the *Times Herald*'s office.

It was from the zoo that I learned that peacocks are not just for the eyes. From my home in the north end, blocks away, I could hear their rippling cries.

There was an unforgettable moment years later: I had kids of my own, and we were picnicking at a table near the elk pen, when I heard a tiny plop and looked down to find that a bird had pooped in my Coke.

And now it is grandkids we take to the zoo. Oh it has been all fancied up now, programs and fundraisers and pizza and frolicking otters and Prairie Dog Town and a fence around the whole thing and you pay to get in, but still it is what it has always been: animals and kids.

Making new histories.

Stan Huskey's history of the Elmwood Park Zoo leads a parade of hundreds—thousands—of other histories. They are the memories and stories of Norristown's people, many of whom saw their first bison or monkey or coatimundi at this landmark location.

—Jerry Spinelli

Jerry Spinelli, famed children's author, who also wrote the introduction to this book, was raised in Norristown and has fond memories of the zoo in his own backyard.

One

THE ZOO TODAY

Search the country from one coast to the next, and it is doubtful you will find a more modern zoo in America.

How many times have you gone to a zoo and wound up on a zip line, cruising across the treetops looking down into a variety of exhibits as you go from one line to another?

Probably never, but you can at the Elmwood Park Zoo.

After your treetop adventure, you can make your way to what has become a ubiquitous fixture across our country—the food truck. Yes, the Elmwood Park Zoo boasts its very own food truck, Sarape's On-The-Go, dishing out incredible Mexican cuisine.

One of the newest additions to the zoo is the red pandas: triplets Clinger, Shredder, and Slash. These cuddly little creatures have become a sensation, almost overshadowing the return of the giraffes to the zoo.

An actual Atlantic City carousel was brought into the zoo to entertain the little ones, along with a new train that gives children a chance to take a break while meandering through part of the zoo. Both have become permanent fixtures.

And for the adults, a new ZooBrew stand has been added near the bison exhibit, serving beer and wine throughout the day. Prism Brewing in nearby Upper Gwynedd Township provides its Tall Blonde, a traditional blonde ale, and the darker, earthier Bison Brown Ale.

Speaking of which, patrons may now hand-feed the bison, as well as the giraffes, during certain times of the day. These two hands-on experiences have become extremely popular, often resulting in lines of people waiting their turn at feeding time.

And by this time, guests are certainly ready to chill out for a while, and that is where Petrucci's Ice Cream Parlor comes in, yet another new addition to the zoo within the past couple of years.

There simply is not a way to enjoy all the zoo has to offer in just one day, which is one of the main reasons visitors are coming back again and again, pushing attendance to more than a half million people a year at this thoroughly modern jewel resting in Norristown, the seat of government of Montgomery County, Pennsylvania.

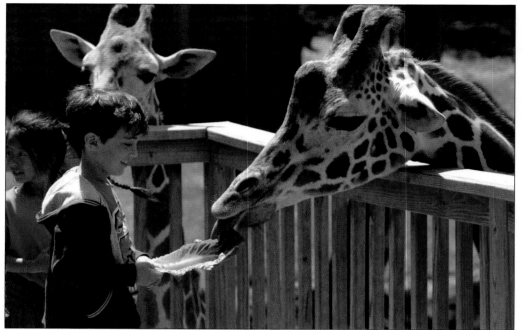

A young visitor to the zoo hand-feeds one of the giraffes that comes to the zoo on loan each year for the summer. For a small fee, visitors can purchase lettuce, and the giraffes will come to them, allowing visitors to touch them and pet them as the reach for the roughage.

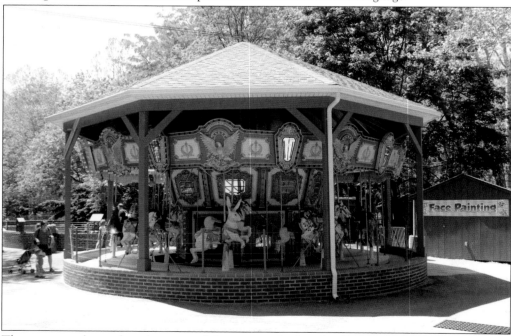

The zoo recently purchased a carousel that was at the boardwalk in Atlantic City, New Jersey. In searching for a carousel, the zoo was conscientious about it not overshadowing the duck pond that it sits next to.

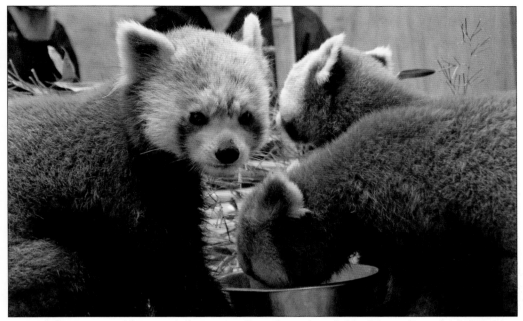

One of the newest additions to the zoo is the red panda exhibit. The red pandas became an instant sensation and are out for the public to see for most of the day.

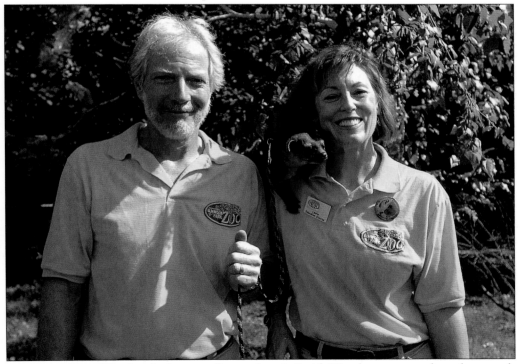

Zoo curator Dave Wood and education director Laurie Smith Wood stop to pose for a photograph with Honey the kinkajou, a rainforest mammal that is a close relative of the raccoon. (Courtesy of Gene Walsh/*Times Herald*.)

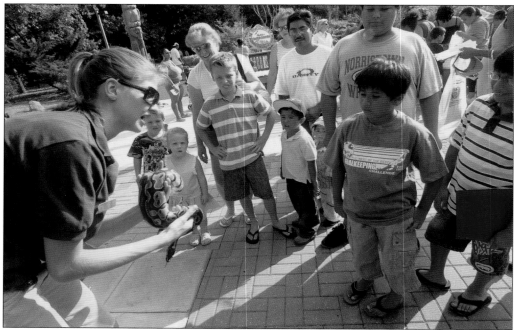

An animal handler at the zoo holds a snake for curious onlookers. (Courtesy of Gene Walsh/ *Times Herald*.)

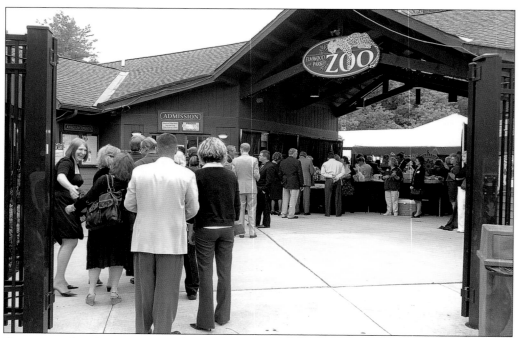

Guests crowd at the entrance to the zoo for one of the many special events that take place after hours at the zoo each year. Zoopendous brings members of the business community out to the zoo each year in an open-air business forum. (Courtesy of Gene Walsh/*Times Herald*.)

Children enjoy the caterpillar train that winds its way through a portion of the zoo grounds, the Danella Garden.

A young visitor is enchanted by one of the sun conures in the zoo's aviary, which is now home to the Birds of Paradise exhibit.

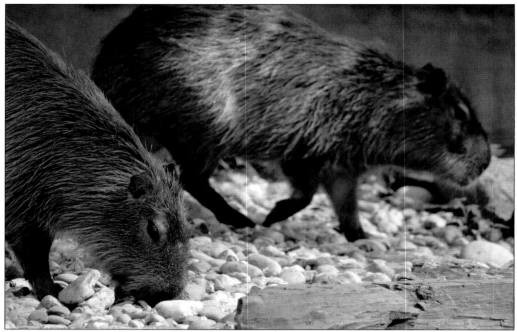

Capybaras make their way down to the pond for a little refreshment. The capybara is the largest rodent in the world, and these two have made their home at the zoo since 2013.

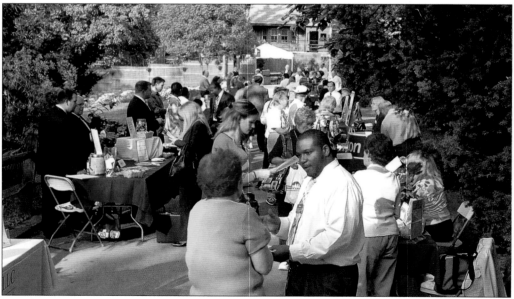

Crowds are large at nearly all of the events held at the zoo, including Zoopendous, which is put on each year by the Montgomery County Chamber of Commerce. (Courtesy of Gene Walsh/ *Times Herald*.)

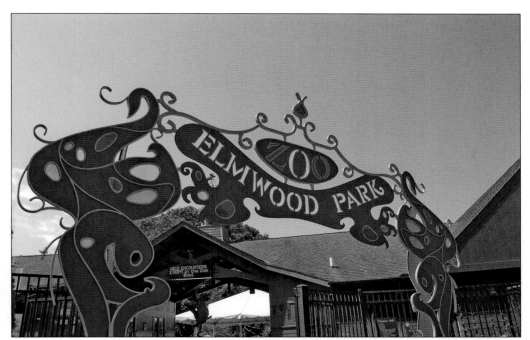

The arch at the zoo's entrance is an intricate piece of artwork designed by local artist Oliver Grimley, a Norristown resident, and crafted by Steve Fierro of Fierro Iron Works in Norristown.

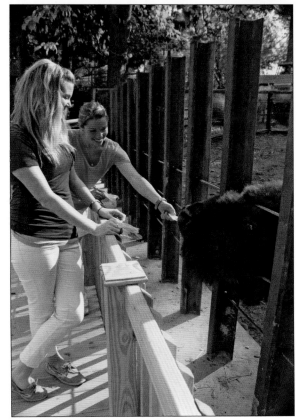

Visitors to the zoo reach out to hand-feed the bison. The opportunity to become more interactive with the bison came about after the success of the hand-feeding of the giraffes.

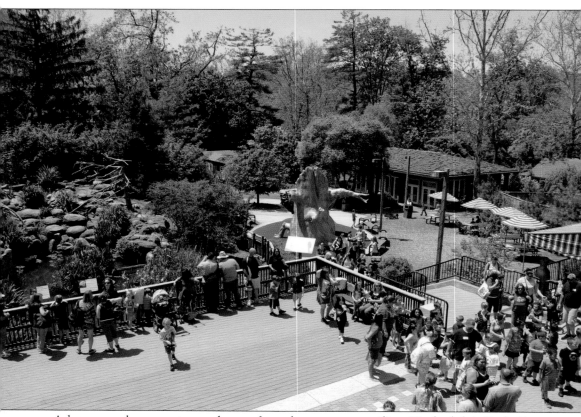

A large crowd peers out over the zoo from the entrance pavilion. To the left is Eagle Canyon, and down the steps and to the right is the new Canopy Gardens Hall, where weddings, business gatherings, and parties of all types are held.

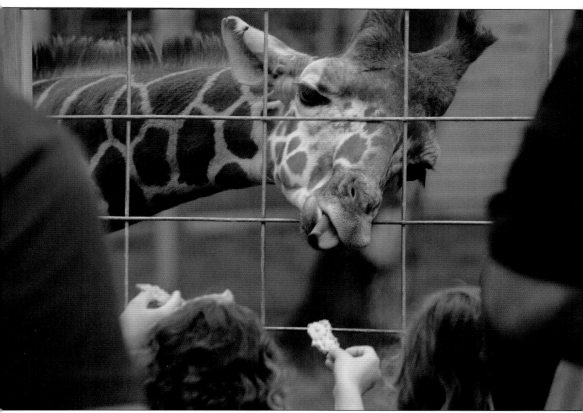

A youngster reaches up to give one of the giraffes what is left of a lettuce leaf. The giraffes come to the zoo each summer and are an instant hit the moment they arrive.

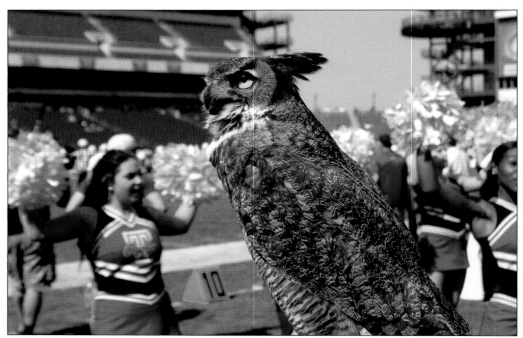

Stella the owl is the official mascot of Temple University. Stella is a great horned owl. The great horned owl is a predator, often taking down prey larger than itself. It is one of the most common owls in North America.

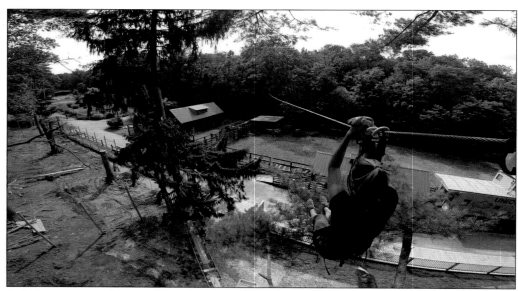

A daring visitor to the zoo takes a plunge on the zip line. TreeTop Adventures runs the attraction, which glides through the woods and over some of the exhibits as well, giving those adventurous types a view of the zoo like no other.

A large gathering is always the order of the day for events at the Elmwood Park Zoo. More than 1,000 people regularly attend the Beast of a Feast fundraiser in the summer and the annual Oktoberfest Beer Tasting Festival.

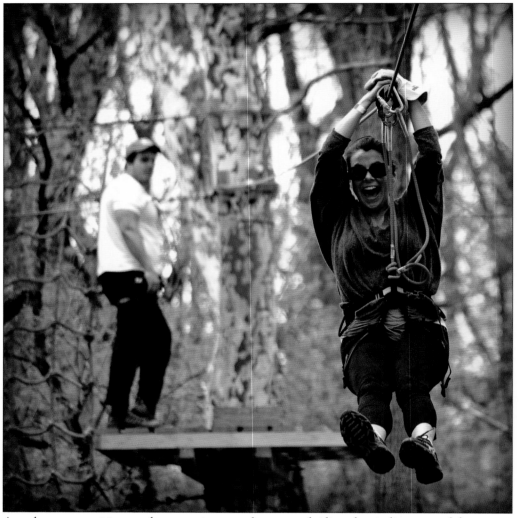

An adventurous visitor to the zoo enjoys an afternoon of riding the zip line, one of the newest attractions at the zoo, which provides visitors of all ages an alternative afternoon of fun. The zip line attraction opened in 2014.

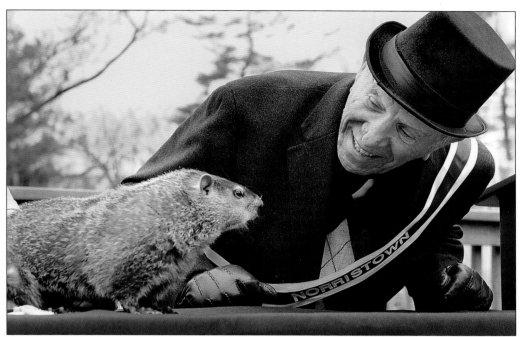

Norristown ambassador Frank "Hank Cisco" Ciaccio says hello to Nora the groundhog. While Pennsylvania may have one of the most famous Ground Hog Day traditions in the western part of the state, Ground Hog Day in Norristown has established a new tradition since Nora's arrival. Nora goes head to head with that other groundhog and has accurately predicted a couple of early springs in recent years. (Courtesy of Gene Walsh/*Times Herald*.)

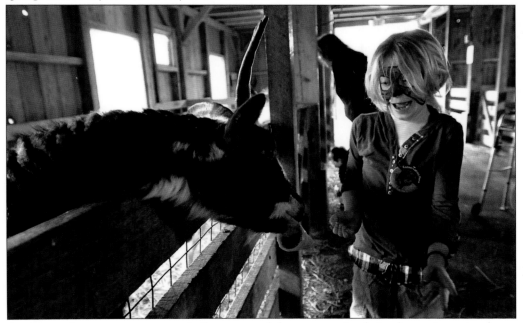

A visitor takes a moment to say hello to one of the many animals in the zoo's petting barn. (Courtesy of Gene Walsh/*Times Herald*.)

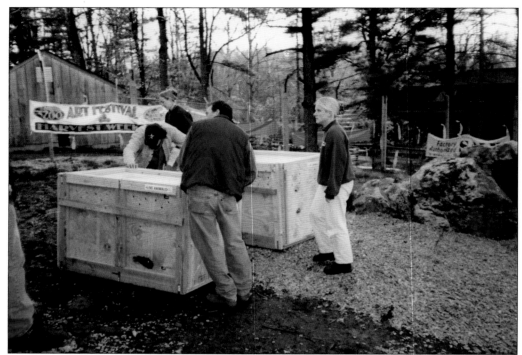

Zoo employees set up for the art festival held each year during Harvest Week. The zoo plays host to a variety of events throughout the year.

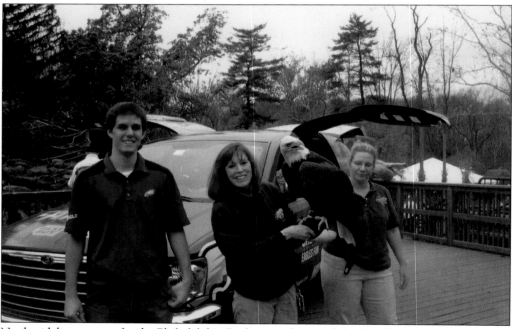

Noah, sideline mascot for the Philadelphia Eagles, seen here with his handler, gets an opportunity to spread his wings, perhaps before heading down to Lincoln Financial Field for a home game. Noah appears along with his counterpart, Swoop.

Two

Over the Years

"Possibly the greatest single improvement" to Elmwood Park was the establishment of the zoo in 1924, read an August 1, 1959, article in the *Norristown Times Herald*. For its 35th anniversary in 1959, the zoo boasted a population of 251 animals and birds, representing 81 species.

Compare that to when the zoo was established and had a mere three whitetail deer and an elk to attract visitors. Elmwood Park was established in July 1909 when Amos Barnes donated 33 acres of land to the Borough of Norristown. The original tract donated by Barnes was bound by Beach and Freedley Streets, from south to north, respectively, and Stony Creek and the Harding Boulevard, west to east, respectively, according to the newspaper article.

In what is described as the first census report on the zoo to Norristown's city council in a March 30, 1960, article, L. Frank Whitehead, parks superintendent, at the request of council chairman Philip Couchara, listed a total of 61 animal species at the zoo, including members of the cat family, monkeys, raccoons, bears, a male buffalo, elk, eland, antelope, sika deer, squirrels, fox, wolves, various birds, ducks, and geese. In 1959, the zoo had 93,451 visitors, six full-time employees, and a total payroll of $23,746.40, which did not include Whitehead's salary of $5,000.

In July 1962, "A new small animal house in Elmwood Park's popular zoo will emerge soon from the draftsmen's board as a joint civic project of the Norristown Lions Club and Norristown Borough Council," according to an article in the *Times Herald*. While there were improvements in the early going, there were also setbacks. Animals were stolen from exhibits, and some animals were able to get out of their cages, causing quite a stir in the surrounding neighborhoods.

Zoo admission was a suggested donation until 1992, when in September of that year it began charging $2 for adults and $1 for children.

As different directors came and went, they all did their best to leave their mark on the zoo, some more than others. At varying times the zoo thrived, but nothing like it does today under the guidance of executive director Al Zone, who has taken attendance at the zoo to never before seen heights. The zoo saw on average about 100,000 visitors a year during the 1990s and 2000s. In 2015, attendance at the zoo exceeded 500,000.

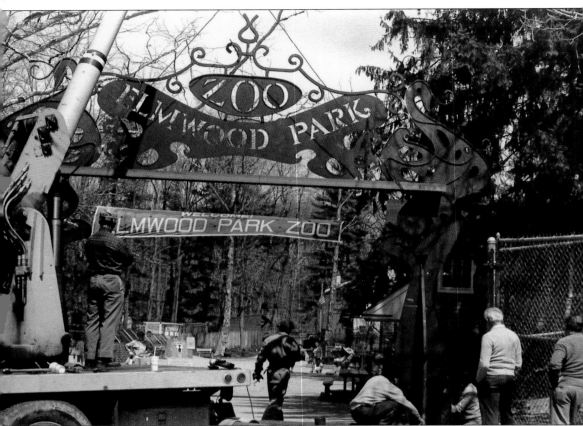

The new entrance to the zoo was installed in 1999, when a decision was made to move the entrance from the south side of the zoo near the bison exhibit to the north side, where a new parking lot was built and eventually expanded to handle the additional cars coming to the zoo each day.

This scene was captured along one of the many pathways that lead visitors throughout the zoo.

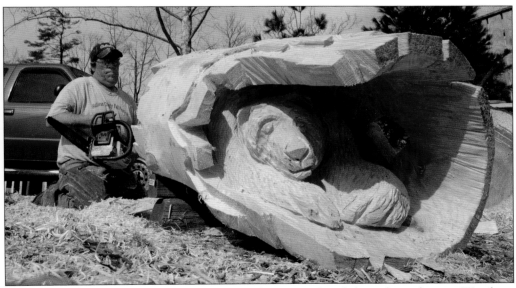

Michael Wood works on one of the many wood carvings found throughout the zoo. Wood, no relation to the zoo's curator Dave Wood, is a master woodcarver. (Courtesy of Gene Walsh/ *Times Herald.*)

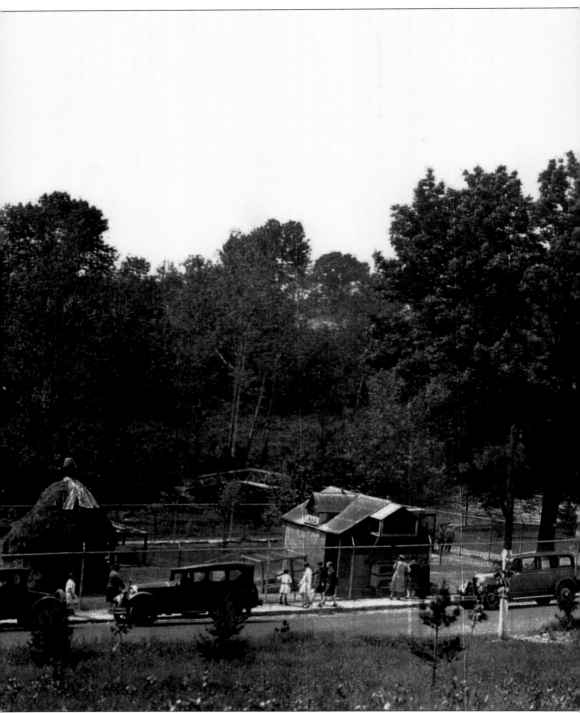

Here is a view of the zoo from Harding Boulevard around 1927. Fences were eventually built all

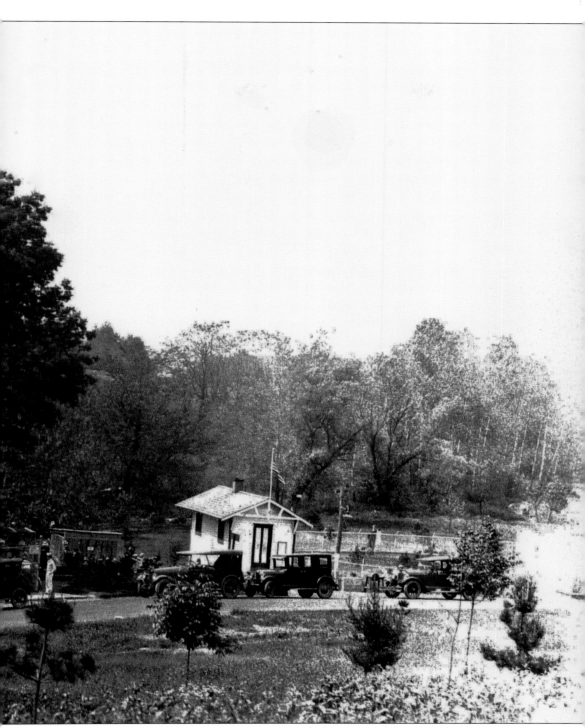

along the boulevard to encourage visitors to come inside for a view of the animals.

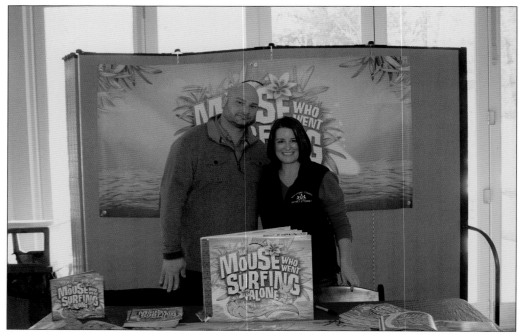

Current zoo director Al Zone poses with Montgomery County district attorney and author of the children's book *The Mouse Who Went Surfing Alone* Risa Vetri Ferman.

Exhibits stand empty in the cold weather, as the animals are brought inside for comfort and their safety.

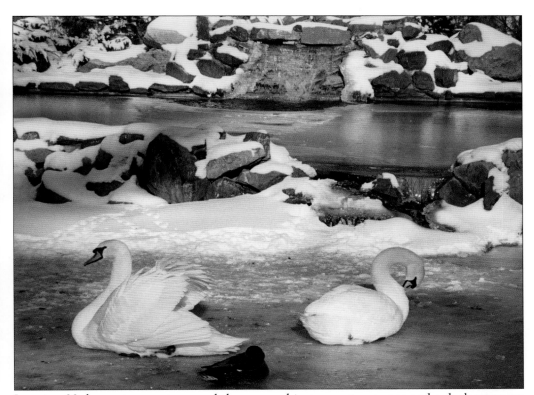

Ignoring 20-degree temperatures and the approaching snow, two swans and a duck preen on the ice at the waterfowl exhibit in Norristown's Elmwood Park Zoo in this January 1984 *Times Herald* photograph by Bob Kratz. Temperatures were expected to drop into the low 20s that night, accompanied by snow, sleet, and freezing rain.

The zoo has always been a place for gatherings. Family and friends alike come in small and large groups to the zoo, especially when there is a special event taking place on the grounds.

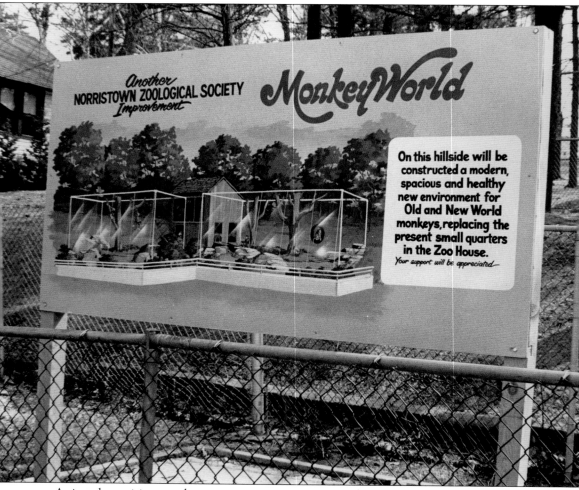

A sign alerts visitors to the newest coming attraction at the zoo, Monkey World. The sign reads, "On this hillside will be constructed a modern, spacious and healthy new environment for Old and New World monkeys, replacing the present small quarters in the Zoo House."

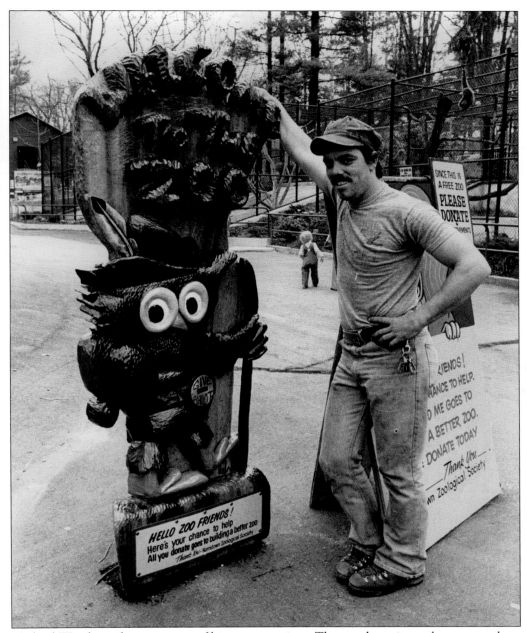

Michael Wood stands next to one of his many carvings. The wood carving welcomes people to the zoo with a note at the bottom that reads, "Hello Zoo Friends! Here's your chance to help. All you donate goes to building a better zoo. Thank You – Norristown Zoological Society."

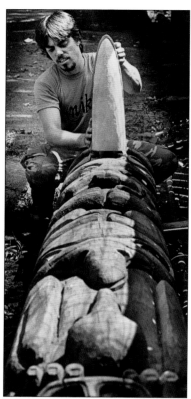

Michael Wood is pictured here with another carving of his, a totem pole. Wood's artistry can be seen throughout the zoo.

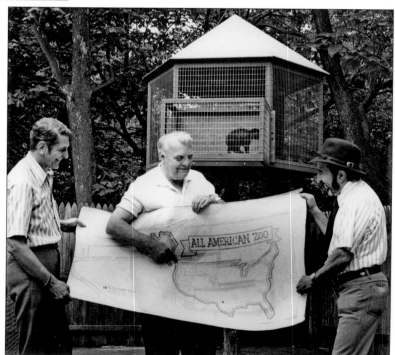

Members of the board of the Norristown Zoological Society look over expansion plans for the zoo.

The entrance to the zoo once stood alone just outside the zoo's gates. This ornamental artwork was created by Oliver Grimley, a Norristown resident and professor of drawing at the Pennsylvania Academy of Fine Arts, and was crafted by Steve Fierro of Fierro Iron Works in Norristown.

Guests at the zoo's 2010 Oktoberfest fundraiser had the chance to enter a raffle to win a brand new Mercedes Benz.

Billy the Beaver, one of many zoo mascots over the years, makes his debut at the ZooBowl in the early 1990s.

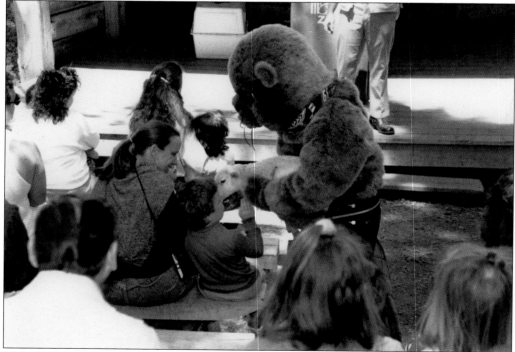

Making friends in the crowd and winning over the children, Billy the Beaver was an active participant in many of the education activities at the ZooBowl. Here he is holding a young sheep up close and personal for one of the children in the audience.

The See to Survive exhibit in the zoo's Sensorium gives visitors an up close and personal view of how animals use their eyes to survive in the wild.

The Senses to Survive exhibit is an overview of all the senses, demonstrating to zoo patrons how animals must depend on all of their senses to survive.

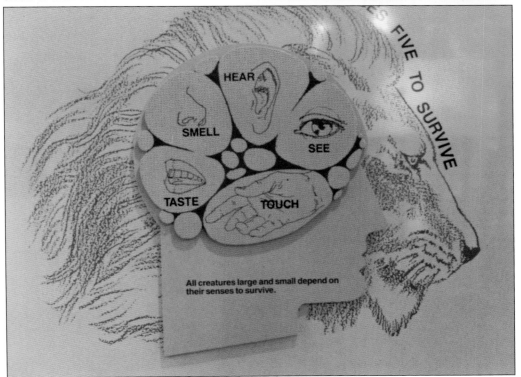

HEAR

SMELL

SEE

TASTE

TOUCH

FIVE TO SURVIVE

All creatures large and small depend on their senses to survive.

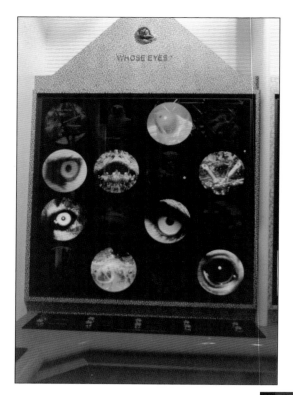

The Whose Eyes exhibit in the Sensorium is one of the more interactive of the exhibits, allowing children and adults alike the opportunity to match animals with the eyes on the display.

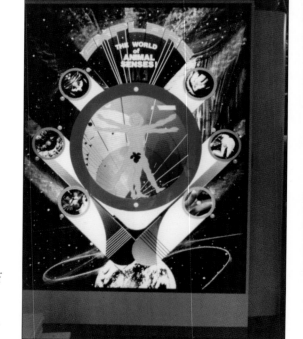

This poster greeted visitors to the zoo's Sensorium exhibit known as the World of Animals Senses. Visitors can learn about animals and their five senses through electronic panels that light up to focus on the nose, ears, and other sensory organs.

In a rare 1926 photograph, Saw, a golden eagle, is seen in his enclosure at the zoo.

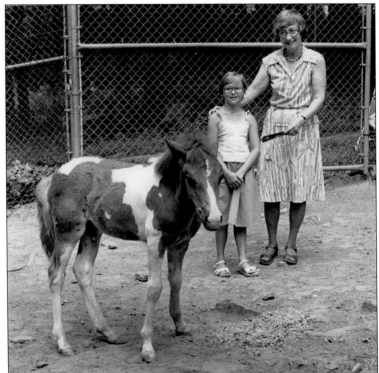

A mother and her daughter are allowed to come into the enclosure with a young Welsh pony, seen in this photograph from 1970. The zoo had two ponies and brought two more in to mate, and they quickly had two new ponies for the children to enjoy.

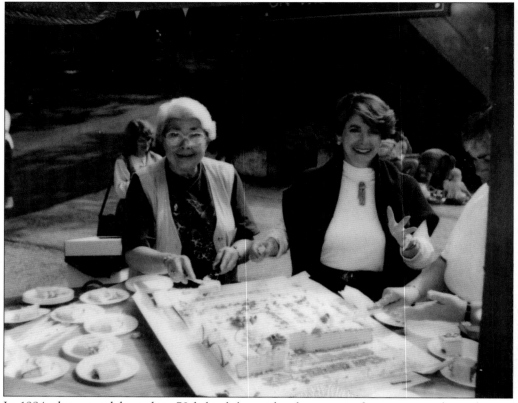

In 1994, the zoo celebrated its 70th birthday with a large party for patrons and members of the zoo.

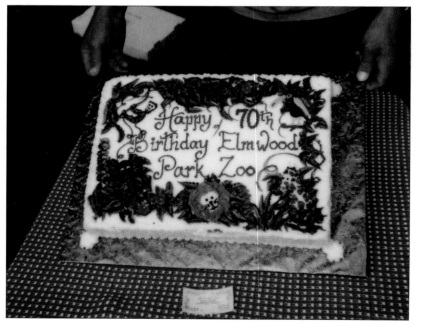

A special cake was baked for the zoo's 70th birthday. The cake, which read "Happy 70th Birthday Elmwood Park Zoo," was decorated with a lion, monkey, elephant, giraffe, and toucan.

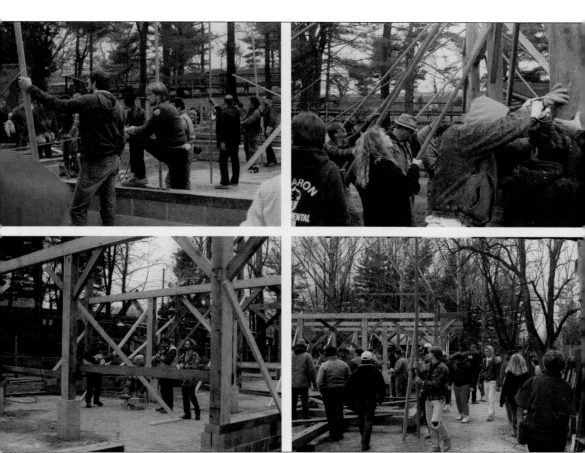

A good old-fashioned barn raising was the order of the day when volunteers pulled together to build what would become the zoo's petting barn in 1990, which still stands today. Children and adults are able to go through the barn, which is home to sheep, ponies, and other small animals, providing another opportunity for visitors to interact with the animals.

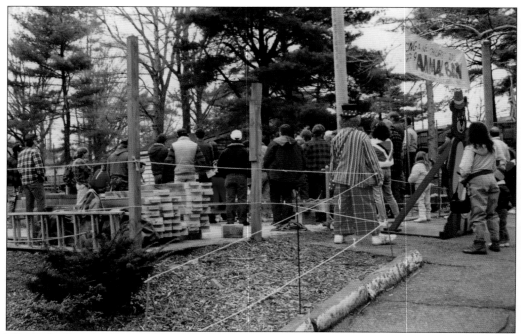

The kickoff to the animal barn raising was turned into a community event, complete with a ribbon-cutting, clowns, and other entertainment.

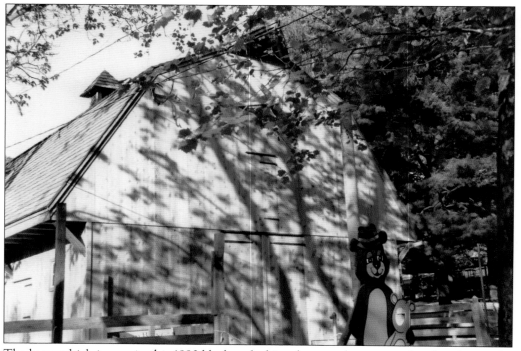

The barn, which is seen in this 1990 black-and-white photograph, was completed in short order with the help of volunteers and community members. Donations to the zoo made the barn raising possible.

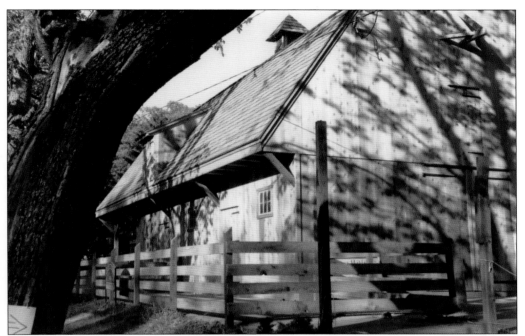

Here is another black-and-white photograph of the completed barn, seen from a slightly different angle. It would not be long before children and their parents made the barn a favorite stopping point at the zoo.

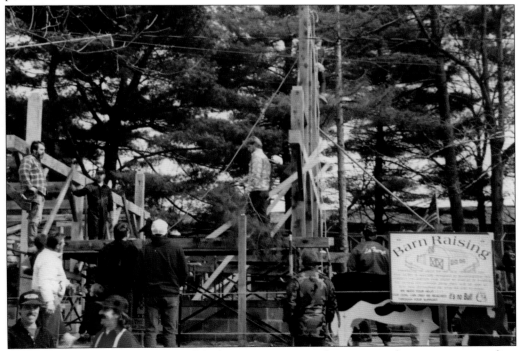

Volunteers begin the second floor of the barn, stopping to make sure everything is going according to plan. The second floor would hold supplies for the animals housed in the barn.

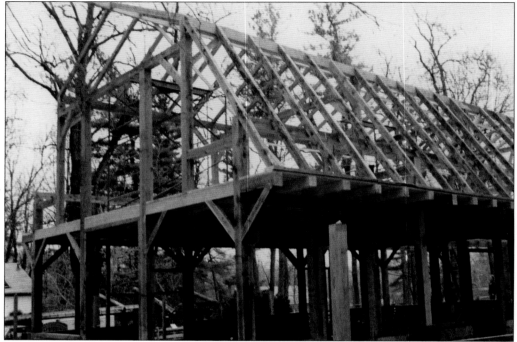

Rafters for the barn's roof are secured into place as construction moves along toward completion. A new roof would soon be nailed down, and the walls would then go up.

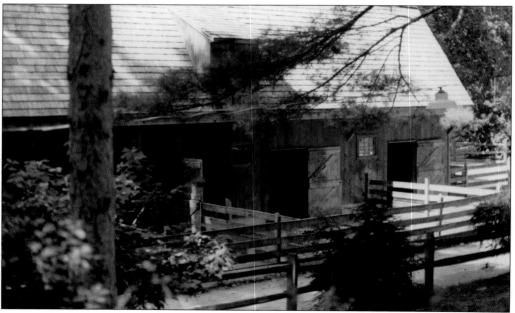

The barn doors are highlighted in this photograph along with the outside fencing at the barn, which allows animals to roam outside for a bit of fresh air.

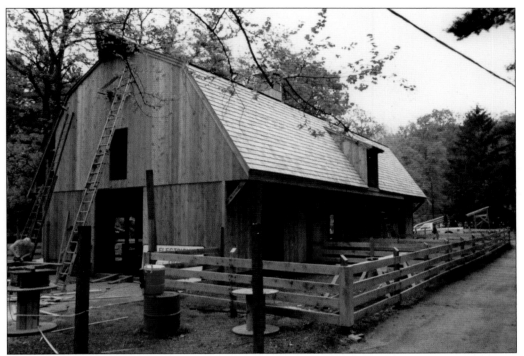

There are two large entrances at either end of the barn to allow zoo workers to get in and out of the barn with necessary equipment to care for the animals.

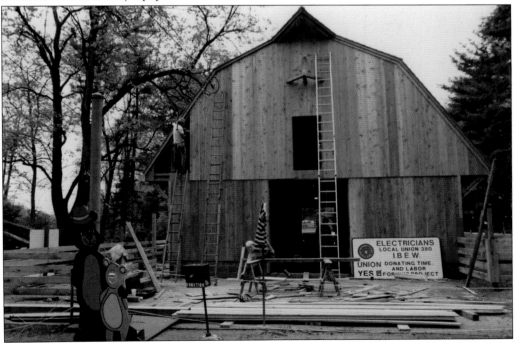

The finishing touches are being put on the barn by, among others, the International Brotherhood of Electrical Workers, who donated time and labor to help in the construction of the new facility.

A new exhibit is under construction. Zoo officials were in the process of transforming as many exhibits as possible to provide the animals with enclosures resembling their natural habitats.

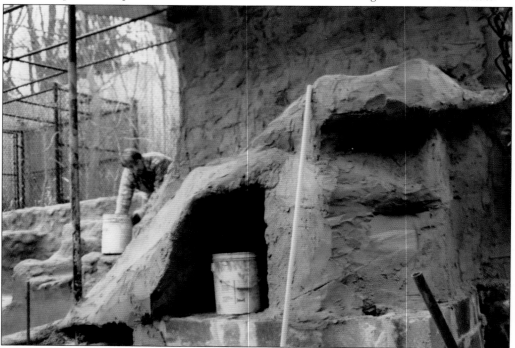

Work continues on the new habitat, which includes a small cave for the resident to retreat into.

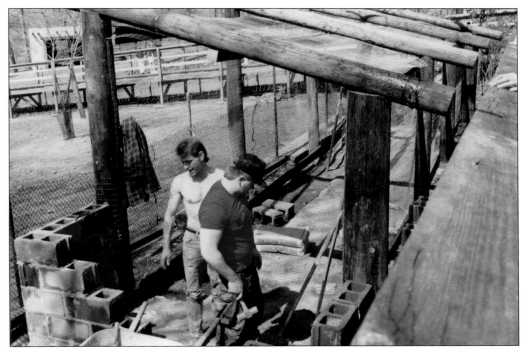

Builders construct the fisher exhibit. The frame for the fisher's new home is taking shape. Notice the cinder block walls being constructed at the side of the enclosure; they will serve as an indoor holding area.

Heavy-duty fencing is going up around the outside of the new fox exhibit, which was constructed in 1990.

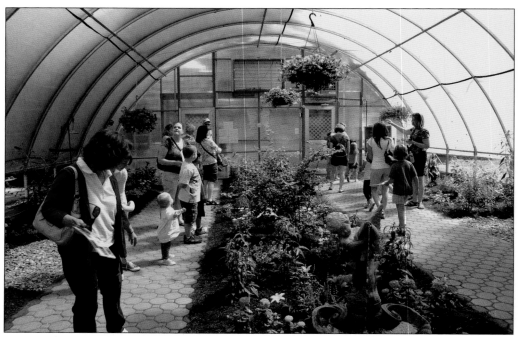

Visitors stroll through the Butterflies and Blossoms exhibit in this photograph from 2010. The butterfly exhibit is now the home of the new Birds of Paradise exhibit, allowing visitors a walk-through experience that puts them inside the entire enclosure.

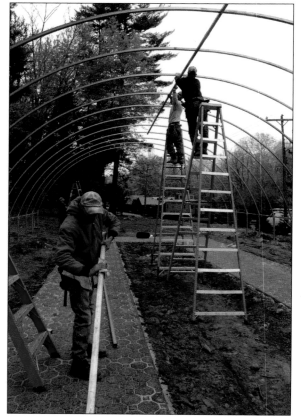

In 2010, construction began on the Butterflies and Blossoms exhibit, and it was completed that year. The exhibit was designed specifically for the breeding and display of butterflies with a special emphasis, as is almost always the case, on education.

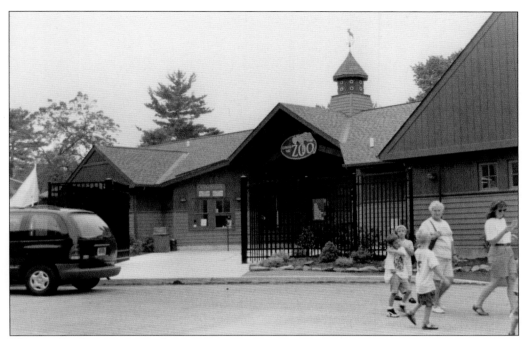

The north-side entrance to the zoo is pictured here before the addition of the decorative arch, which was created by local artist Oliver Grimley and crafted by Steve Fierro of Fierro Iron Works.

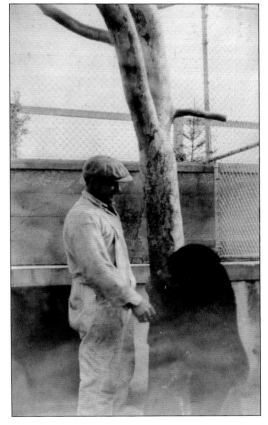

In this 1926 photograph, a zookeeper is seen with a black bear. The keeper is inside the bear exhibit and appears to be hand-feeding the relatively young cub.

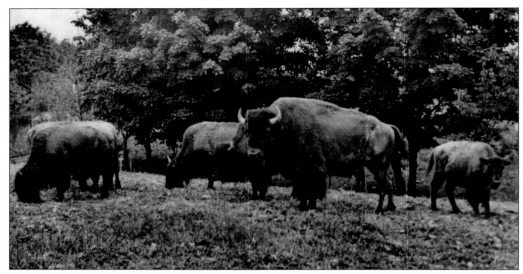

Bison appear to be roaming freely in this 1926 photograph. The zoo was just two years young at the time, and there were not nearly as many animals as there are today, so those that did call the zoo home had large swaths of land to call their own.

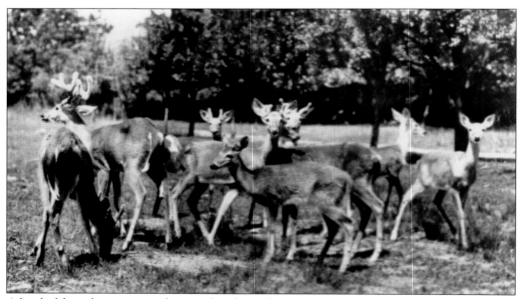

A herd of deer also appears to have its fair share of space in this 1926 photograph. The zoo began with a donation of land and "a few whitetail deer," according to a *Times Herald* article. These could be the earliest inhabitants of the zoo, which is now in its 92nd year.

A woman appears to be feeding a goat through the exhibit's enclosure, an activity that is completely prohibited today.

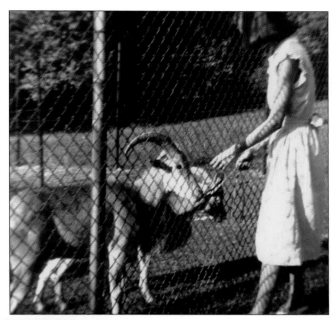

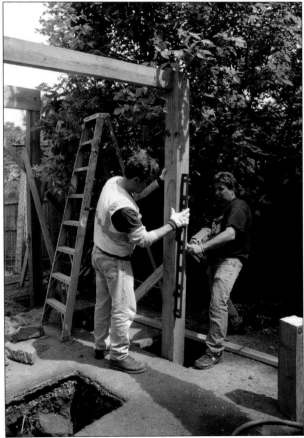

Providing and upgrading shelter for the animals at the zoo is an ongoing venture. Here workers level the support beams for a new bighorn sheep enclosure.

Construction on the new entrance to the zoo is pictured here from inside the confines of the zoo. The steps lead down to the main path inside the zoo grounds. The gift shop is on the left, and administration offices are on the right.

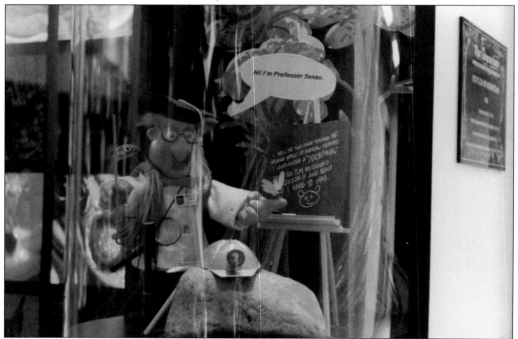

Professor Senso welcomes visitors to the zoo's Sensorium. The Sensorium is where visitors can learn about animals and their five senses through electronic panels that light up to focus on the nose, ears, and other sensory organs, the first of its kind in the country.

Three

THE MORTON "BUBBY" WEISS ERA

Morton "Bubby" Weiss was a force of nature.

His contributions to Elmwood Park Zoo cannot be denied, just as he could not whenever he was on a mission.

That mission appears to have taken root in the mid-1960s. "Morton L. Weiss, Norristown businessman who made possible the purchase of one of the zebras with a sizable contribution, also will be introduced," read a June 3, 1967, article in the *Times Herald* about the upcoming Zoo Day observance.

Weiss was the owner of Gilbert's in the 100 block of West Main Street in Norristown.

There were innumerable changes under Weiss's direction, including the Sensorium in 1988 and the ZooBowl Theater the year before, which transformed the small-town zoo into a nationally recognized wildlife preserve. The Sensorium was an indoor exhibit in which visitors could learn about animals and their five senses through electronic panels that light up to focus on the nose, ears, and other sensory organs, the first of its kind in the country, Weiss said in a July 1990 article in the *Times Herald*. Under Weiss, the zoo also saw the creation of the duck pond, Monkey World, Cougar Country, and Zoo America.

In 1987, then-mayor John "Barney" Marberger vetoed a move by council at its February 5 meeting to transfer operations of the zoo from the borough to the Norristown Zoological Society. About a month later, council voted 8-3 to override the veto. The Norristown Zoological Society was now in the full control of the Elmwood Park Zoo.

During Weiss's tenure, entrance to the zoo was free with a suggested donation. However, it was not long after Weiss retired from the Norristown Zoological Society in July 1990 that economic realities began to set in. In September 1992, the zoo first started charging for admission, $2 for adults and $1 for children. Those who could not afford to pay were admitted for free on Tuesday and Thursday afternoons. Admission prices have gone up over the years to keep pace with inflation, but it is still one of the best values around, and there is no time limit for visitors; come in the morning and stay all day.

Zoo diners, joining in the celebration of the annual Elmwood Park Zoo Supper on July 23, 1985, in Norristown are, from left to right, Norristown mayor John Marberger, Councilman Dennis Caglia, Norristown Zoological Society membership chair Lenore Weiss, and society president Morton "Bubby" Weiss. (Photograph by Gene Walsh, courtesy of the *Times Herald*.)

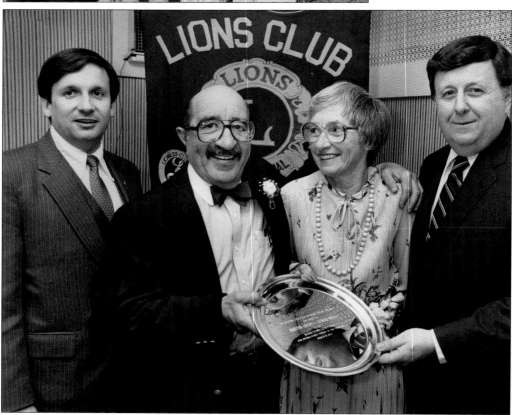

The annual Eugene Seltzer Humanitarian Award of the Norristown Lions Club was presented to Bubby Weiss in March 1985 by Lions program chairman Guido Martinelli, far right. At left is club president Chuck Rogala. Joining Weiss is his wife, Lenore Weiss. The award, acknowledging community service, was presented at a dinner attended by more than 100 people at the Jefferson House Restaurant in East Norristown. The Weisses have been active for more than 30 years in Norristown business and civic affairs. (Courtesy of Paul Piantone.)

Bubby Weiss stands before the entrance to the Sensorium at Norristown's Elmwood Park Zoo in this May 26, 1990, *Times Herald* photograph by Bill Landis. As visitors entered the Sensorium, they faced a checkerboard wall made up of rear-lighted panels and dark areas depicting senses and information on animal senses. Weiss was expected to relinquish the presidency of the Norristown Zoological Society in September of that year. (Courtesy of Paul Piantone.)

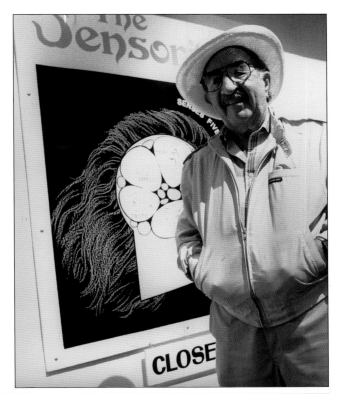

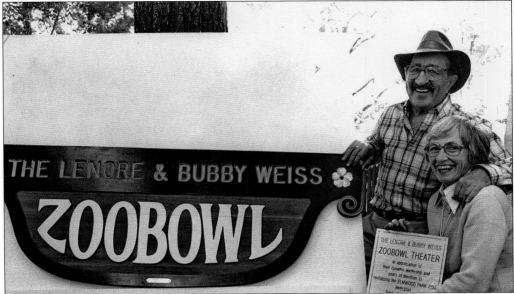

New at the zoo, Bubby Weiss, president of the Norristown Zoological Society, and his wife, Lenore, are honored with the dedication of the ZooBowl Theater on September 16, 1984, at Elmwood Park Zoo in this *Times Herald* photograph by Bruce Phipps. Festivities included a ribbon-cutting ceremony, folk songs, live animal shows, and a slide presentation on the borough zoo. (Courtesy of Paul Piantone.)

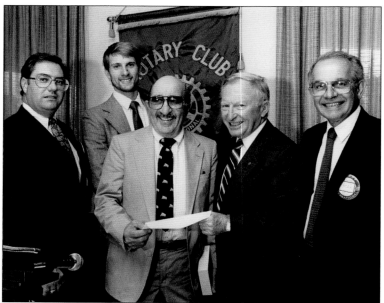

Norristown Rotary Club community service coordinator Berk Ellis, second from right, presents a $300 check to Norristown Zoological Society president Bubby Weiss. Others in attendance at the club's September 29, 1988, meeting are, from left to right, Rotary president Don Black, zoo director Steve Jagielski, and program chairman Dr. Max Herman. (Courtesy of Paul Piantone.)

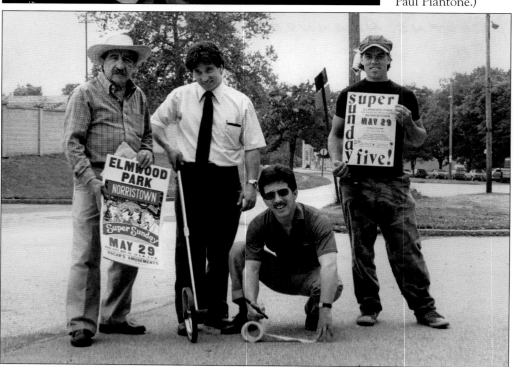

Getting ready for Super Sunday and preparing for heavy demand, officials of Norristown Super Sunday 5 spent the day before aligning space on Harding Boulevard for vendors' booths in this May 1983 *Times Herald* file photograph. Busy with the tape measure and marking pen are, from left to right, Bubby Weiss, Super Sunday chairman Paul Piantone, booth committee chairman David N. Caramenico, and committee member Michael Wood. The event ran that Sunday from 12:00 p.m. to 6:00 p.m. (Courtesy of Paul Piantone.)

Pictured here in November 1988, newly elected officers of the Norristown Zoological Society are, from left to right, (first row) Paula Wellard (vice president) and Rita Riccardelli (secretary); (second row) Paul Piantone (treasurer), Bubby Weiss (president), and Lenore Weiss (membership chair). The election was held at the senior adult activity center in Norristown. (Courtesy of Paul Piantone.)

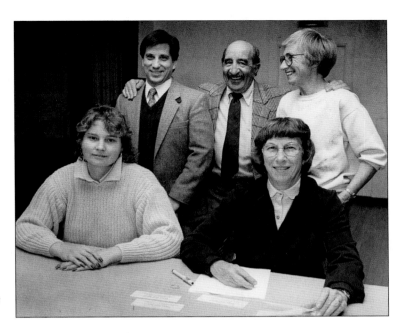

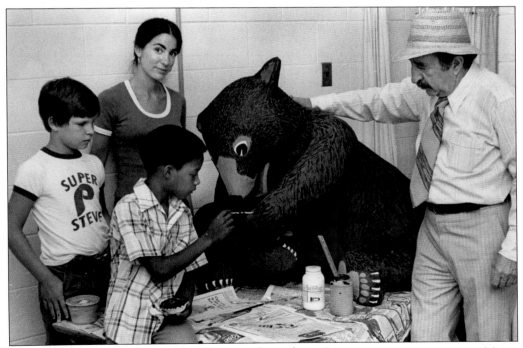

Zoological Society president Bubby Weiss introduces the zoo's new mascot to some young visitors. There have been a number of mascots at the zoo throughout the years, and now the zoo is providing mascots to local athletic teams, including Noah the eagle, the new sideline mascot for the Philadelphia Eagles, and Stella the owl, the new mascot of the Temple University Owls. (Courtesy of Paul Piantone.)

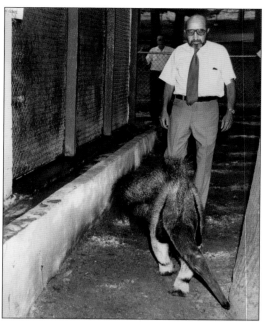

Bubby Weiss is pictured here with one of the more unique animals to call Elmwood Park Zoo home, an anteater, or aardvark, making its way through one of the barns at the zoo. (Courtesy of Paul Piantone.)

Zoological society president Bubby Weiss was presented with the 18th-Annual Distinguished Service Award from the Greater Norristown Jaycees. The presentation was made at a dinner dance hosted by Joseph Powell (center), the Jaycees' area chairman. Lenore Weiss joined her husband for the event. (Courtesy of Paul Piantone.)

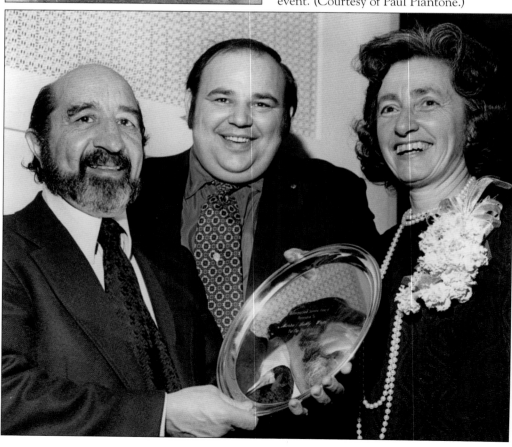

Four

EXECUTIVE DIRECTORS
THROUGH THE YEARS

Executive directors at Elmwood Park Zoo could have been considered on the endangered species list, especially during the 1980s.

In 1988 alone, three different directors took the helm.

Mark Thurston was curator from December 1985 to 1987. It was during the end of his tenure that Weiss and the zoological society were attempting to wrest control of the zoo from the borough. When Thurston become curator in 1985, he said at the time he found himself fighting an uphill battle all the way, according to a February 1987 article in the *Times Herald*. "I never realized that nearly every decision made in this town would have political ramifications," Thurston quipped.

The article appeared about three weeks before council voted to override then-mayor John Marberger's veto of council's vote to turn control of the zoo over the zoological society, headed by Morton "Bubby" Weiss.

Weiss was quoted as saying he had no allegiance to Thurston and Thurston and the three current zoo keepers would become borough employees, adding that he felt little cooperation on Thurston's part since he replaced the previous curator, Paula Wellard, the article continued.

John Kauffman, 24, director for less than a year in January 1988, walked out along with all of the staff. There were three keepers at the time.

In June 1988, George Speidel, 45, was replaced by Stephen Jagielski, 26, a former employee of the Bronx Zoo in New York. In 1993, Stephen Jagielski was fired over philosophical differences, according to a story in the *Times Herald*. Jagielski became the third person in six months to be named director. He held onto the spot much longer than his most recent predecessors.

The zoo prospered under Jagielski, opening the extremely popular petting barn and concentrating on showing North American wildlife.

In July 1999, Steven K. Marks became the director of the zoo. Marks, 36, of Quakertown, began his career as a veterinarian at the Quakertown Veterinary Clinic before working as a senior veterinarian at the Pittsburgh Zoo. One of Marks's first contributions to the zoo was an interactive prairie dog exhibit, which is still on the grounds today.

Current executive director Al Zone came to the zoo in 2011, and he has been constantly upgrading the facility. Bringing the giraffes to the zoo was one of his earliest successes. Attendance skyrocketed while the giraffes were at the zoo throughout the summer, and he has brought them back every year. When Zone arrived, attendance was at a little more than 100,000 patrons a year. In 2015, the zoo topped the half-million mark in visitors.

Former zoo director Bill Konstant, who became executive director in January 2009, is pictured here checking on one of the exhibits. (Courtesy of Gene Walsh/*Times Herald*.)

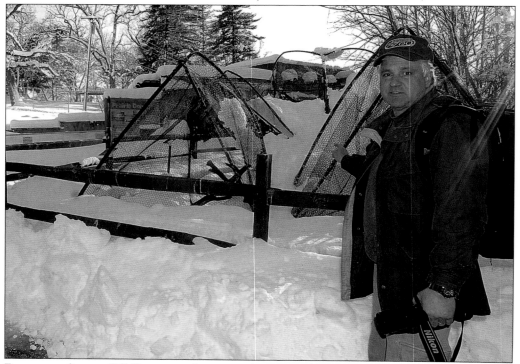

Former zoo director Bill Konstant, who resigned in November 2011, is standing outside the prairie dog pens during a deep snow. (Courtesy of Gene Walsh/*Times Herald*.)

Pictured here is an early iteration of Canopy Gardens Hall at the zoo. The pavilion has since been completely closed in and restrooms were added to the structure, making it a complete banquet hall for parties, receptions, and weddings. (Courtesy of Gene Walsh/*Times Herald*.)

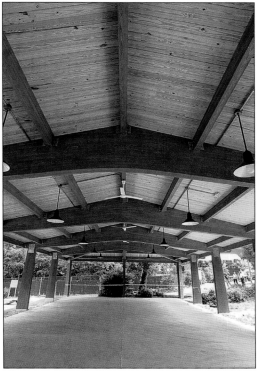

Pictured here is former zoo director Raphael Suarez. Suarez joined the zoo in 2003 and became executive director in 2005. He left the zoo in mid-2008. (Courtesy of Gene Walsh/*Times Herald*.)

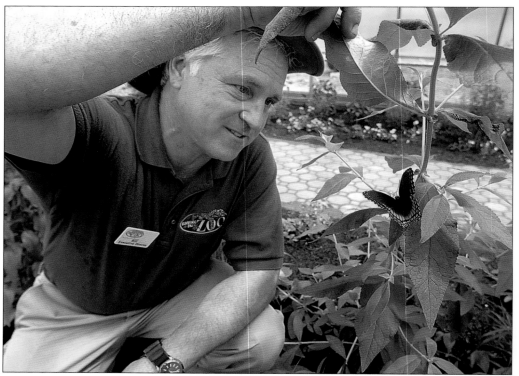

Former zoo director Bill Konstant takes a close look at a butterfly inside the zoo's former Butterflies and Blossoms exhibit.

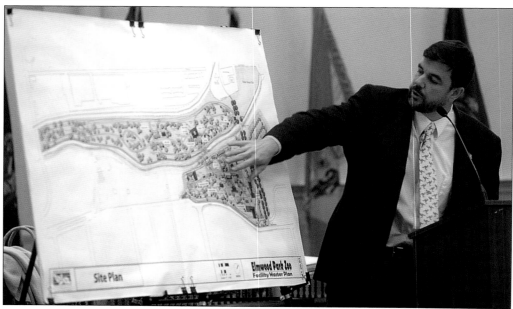

Former zoo director Steve Marks goes over plans for an expansion at the zoo with Norristown Borough Council. The zoo has seen many changes since the 1980s, when the Norristown Zoological Society was first formed.

Five

Children Are
the Cornerstone

Zoos are for children.

While adults love to stroll through the grounds of Elmwood Park Zoo, the awe appearing in children's eyes as they come upon another exhibit is worth so much more than the price of admission.

And perhaps no other zoo goes to such great lengths to entertain the youngest of visitors as Elmwood Park Zoo.

In the early 1970s, as the finishing touches were being put on the children's zoo, a Malayan sun bear named Hercules arrived in Norristown to the delight of thousands, including Kathryn Rehrig, whose letters to the Newark, New Jersey, humane society and to then-governor Milton Shapp were instrumental in getting the small black bear to Norristown.

"This is a wonderful day for the zoo and especially for the children," said Norristown's parks and playgrounds committee chairman Claude Tyson of Hercules's arrival.

The Malayan sun bear's arrival garnered national attention as well when the young cub's story was told to millions of viewers of the *Dick Cavett Show*, according to the *Times Herald*.

Two lion cubs also arrived at the zoo during that same time, in 1971. A few years earlier, in 1965, a small group of children at Rittenhouse Junior High were saddened when they heard about a deer being killed in the zoo. Their student council got together and raised $75, enough to buy a new deer for the zoo.

Other animals that made their home in the newly created children's zoo included macaws, monkeys, ponies, and donkeys.

Children have also contributed to the zoo over the years, including a 15-year-old aspiring Eagle Scout. Josh Lippy, who was heading into his sophomore year at Norristown Area High School in 1990, oversaw the construction of a pen for fishers, a nocturnal forest animal found mostly in Canada and the northeastern part of the United States. Lippy designed the pen, the newest exhibit in the zoo at the time, and constructed it along with help from other members of Audubon Scout Troop 573.

Students at the Central Montgomery County Area Vocational Technical School built the padded benches that were used in the newly opened Sensorium in 1989.

In 1993, a children's garden opened up to all youngsters the opportunity to touch and smell and walk through some of the plants in the garden. The garden included a bird sanctuary and a bird blind so children could watch birds at the newly installed bird feeders.

A zoo just would not be complete without a mascot to make the children smile. Billy the busy beaver was introduced at the grand opening of the children's zoo barn. Bubby the Bison is the newest mascot to join the zoo family.

A group of children and their parents walk along the main walkway in the zoo. To their left is the very beginning of what is now Canopy Gardens Hall. (Courtesy of Gene Walsh/*Times Herald*.)

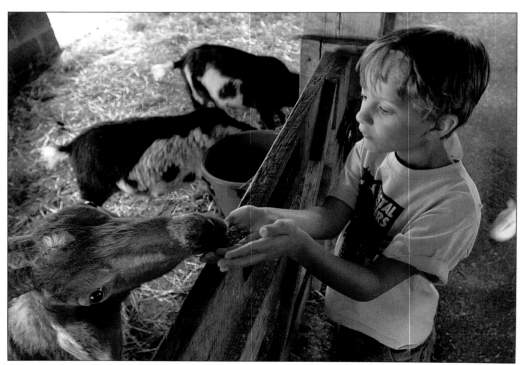

A young visitor is enthralled by a goat in the petting zoo. The animal barn was an instant success after it was built. Children and adults are able to go through the barn, which is home to goats, sheep, ponies, and other small animals. (Courtesy of Gene Walsh/*Times Herald*.)

Christmas at the zoo is a magical time. The zoo holds a number of events throughout the year for children and adults alike. There is the Zoo Snooze in the summer for the kids and an Oktoberfest in the fall for adults to enjoy.

A group of children gathers for a photograph at the zoo. Children have always been a major focus for the zoo, where educating youngsters on animals native to North America is a priority. Kids ages three to five are able to interact with educational animals through the zoo's Litter Learners program.

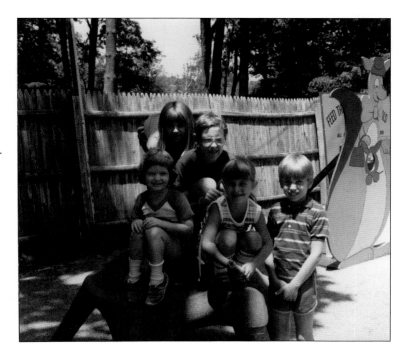

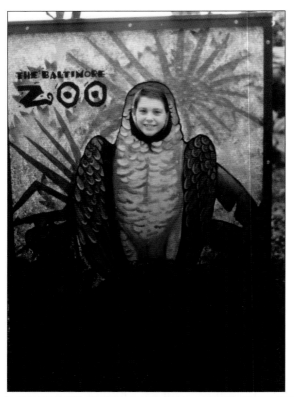

A young zoo patron has his photograph taken at the Baltimore blue-and-gold macaw cutout. There are several cutout signs throughout the zoo for young and old alike to have photographs taken and preserve the memory of their visit to the zoo.

A family poses for a photo opportunity in front of one of the first exhibits down the main path at the zoo. The exhibit where they have stopped is now the home of the zoo's cougar.

While there is plenty to learn at the zoo, the staff is also always willing and ready to make sure the younger visitors have a great time when they visit. Pictured here is a giant inflatable slide set up at one of the zoo's many special events throughout the year.

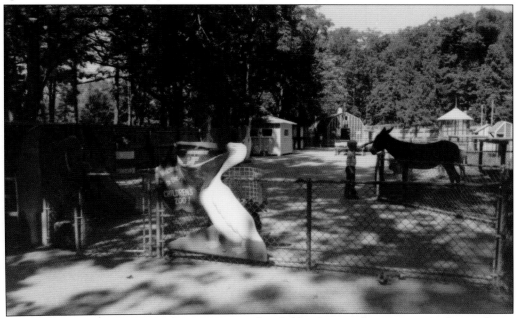

A pelican awaits donations at the entrance to the children's zoo, where a variety of animals are always eager to greet the youngsters, including the donkey seen here. Other animals that make their home in the zoo include macaws, monkeys, and ponies.

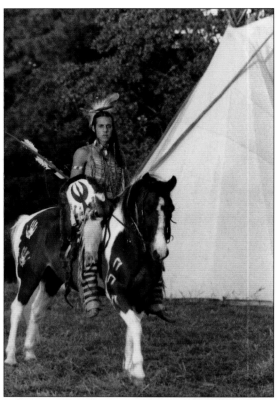

A member of the Eastern Band of the Cherokee Nation is seen here on horseback. The Eastern Band of the Cherokee Nation is one of only three federally recognized tribes of Cherokee. Education plays an important role at Elmwood Park Zoo, and hosting a member of a significant Native American tribe brings the nation's history alive.

Children sit engrossed while watching a member of the Eastern Band of the Cherokee Nation use his bow and arrow to strike a target. Native Americans were expert marksmen with the bow and arrow, which they used when hunting for food for survival.

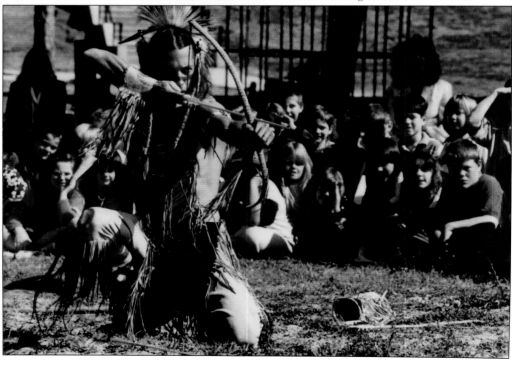

Face painting is just one of the many children-focused events at the Elmwood Park Zoo when a special occasion arises, including this afternoon of fun in 1996.

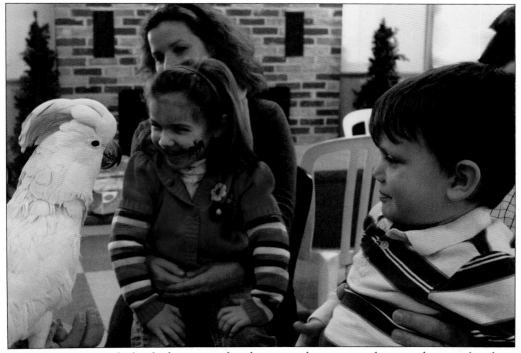

Birthday parties can be booked year-round at the zoo, and no matter who is on the guest list there is sure to be an additional partygoer popping in. The zoo's Moluccan cockatoo is brought out to the delight of all the children at this particular celebration.

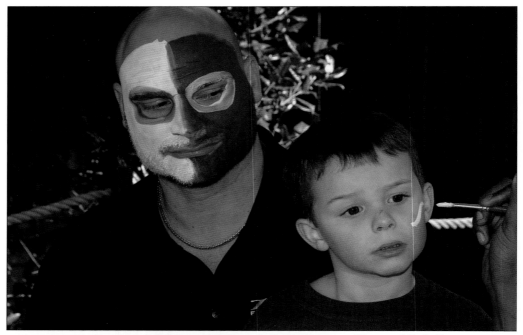

Elmwood Park Zoo executive director Al Zone and his son get into the spirit at a Philadelphia Eagles pep rally in 2010. Face painting is almost always a big hit with the children—and sometimes the adults.

Children play next to a statue at the zoo. The zoo tries its best to cater to children, and there are a number of objects around the zoo to attract their attention.

Six

ANIMALS THROUGH THE YEARS

Elmwood Park Zoo began with a handful of whitetail deer and has expanded greatly over the years. There were animals from all over the world at one point during the 1960s and 1970s, but then an effort was made to rebrand the zoo and concentrate on animals indigenous to North America.

There is not an accurate accounting of the arrival and departure of all of the animals that at one time called Elmwood Park Zoo home, but below are some of the more memorable animals.

In 1966, a three-year-old tiger came to the zoo on loan from Warren Buck, a famed animal trainer. The tiger was housed in the cage next to Isabel, the zoo's lioness, joining other jungle animals, including a chimpanzee, a leopard, and a baboon.

Mollie the elk, at 26 years old in 1977, was considered the oldest living elk in captivity in America.

Dusty, a Welsh pony, came to the zoo in 1978 and joined others already living there. In 1979, she gave birth to a foal, bringing the number of the herd to five.

The prairie dog village was constructed in 1979 in an ongoing effort to allow visitors to see the animals in their natural habitat.

During the same period in 1979, a bear cage was converted into a new home for a gibbon. Another gibbon arrived at the zoo in 1990. In 1980, a capuchin monkey named B.J., or Bubby Junior, for Morton "Bubby" Weiss, was the first of two born at the zoo. The second, Louie, was born in 1981.

In 1985, the Cougar Country habitat opened to the public. Two cougar cubs, or mountain lions as they are also known, were purchased the year before and held in temporary housing while the new exhibit was being built.

The zoo had three Burmese pythons in 1985, the largest of which grew to 14 feet long and weighed 60 pounds.

An American bald eagle came to the zoo in February 1990. The eagle was first taken to the Baltimore Zoo, where it had its right wing amputated. The eagle had been shot, and the wing could not be saved.

Others notable inhabitants and their arrival dates include a rhesus monkey named Cashew (July 1987), three kestrels (1990), a wolf (1992), a western golden eagle (June 1979), two hawks, a red-tailed and a Swainson's (January 1979), black bears Toby and Tater (March 1990), and Merlin, a three-year-old female bobcat (July 1989).

A golden eagle named Kansas was stolen from the zoo in July 1992.

A pair of giraffes—Dhoruba and Jukuu—arrived for a summer visit in 2013. Other giraffes have made stops at the zoo, but Dhoruba is a crowd favorite.

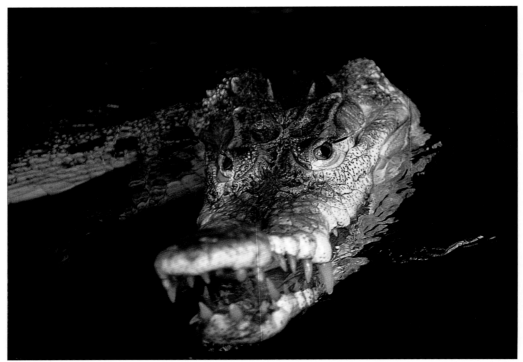

Seen here is one of the crocodiles once found in the Bayou exhibit. The Bayou exhibit took the place of the Sensorium. (Courtesy of Gene Walsh/*Times Herald*.)

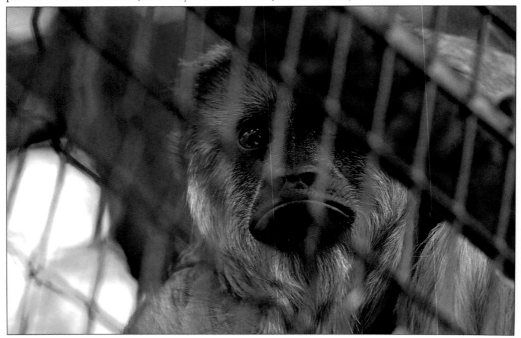

A howler monkey peers out of its enclosure. Howler monkeys are one of the few nest-building monkeys. (Courtesy of Gene Walsh/*Times Herald*.)

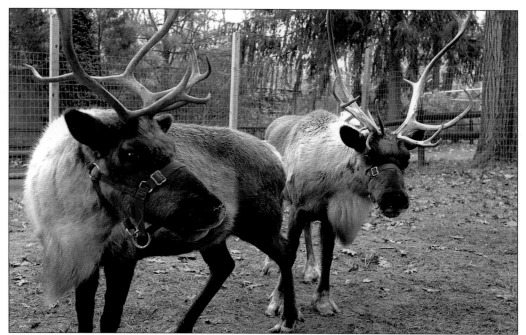

Reindeer stand at the ready at Elmwood Park Zoo, awaiting orders from Santa. Reindeer are native to North America and are sometimes also known as caribou. (Courtesy of Gene Walsh/ *Times Herald*.)

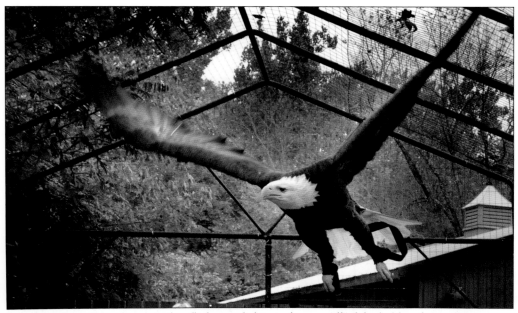

Noah, a bald eagle at the zoo, takes flight inside his enclosure. All of the bald eagles at the zoo were brought to the zoo because of injury. Their injuries would have proved fatal in the wild; instead, they live comfortably and well cared for at the zoo. (Courtesy of Gene Walsh/*Times Herald*.)

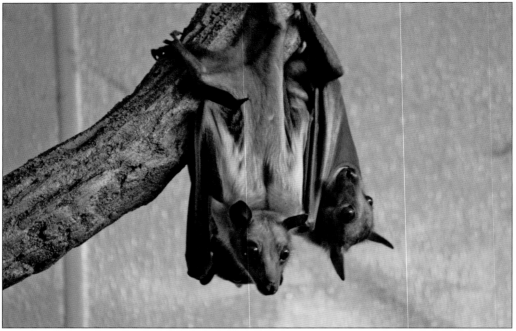

The fruit bats make a day of just hanging out at the zoo.

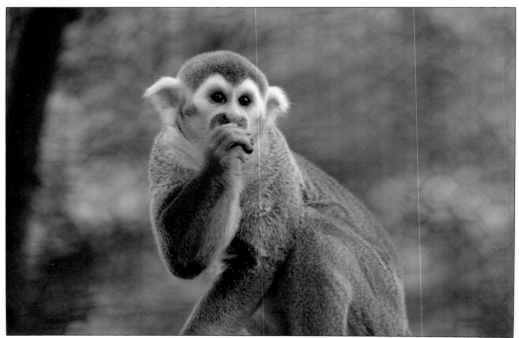

One of the zoo's squirrel monkeys takes time out of his busy day to watch visitors to the zoo. Squirrel monkeys are indigenous to Central and South America.

The majestic jaguar has been one of the most popular animals at the zoo for many years, and residents have come to know most by name, including the two newest additions to the family, Inka and Zean. (Courtesy of Gene Walsh/*Times Herald*.)

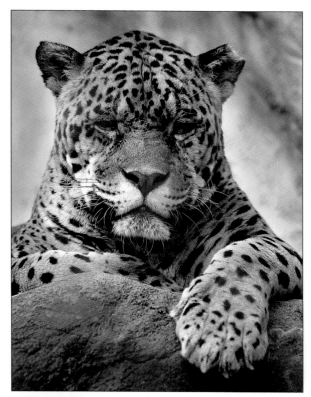

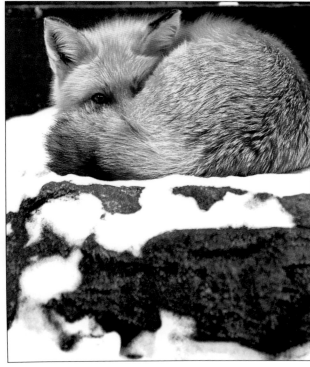

A red fox curls up for an afternoon nap in the snowy confines of his habitat. (Courtesy of Gene Walsh/*Times Herald*.)

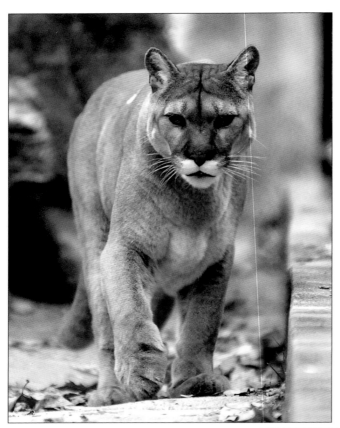

A cougar appears to be stalking its prey but in reality is simply taking a walk during a sunny afternoon at the zoo. (Courtesy of Gene Walsh/*Times Herald*.)

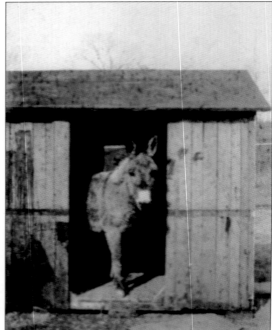

A donkey peers out from one of the barns at the zoo. There are several houses for the animals throughout the zoo in addition to their regular habitats.

Monkeys enjoy the afternoon. Monkey World was a very popular addition to the zoo, providing a healthy new environment for Old and New World monkeys.

The gibbon, a species of ape, was one of first animals to be seen when visitors used to enter the zoo on its park-side entrance.

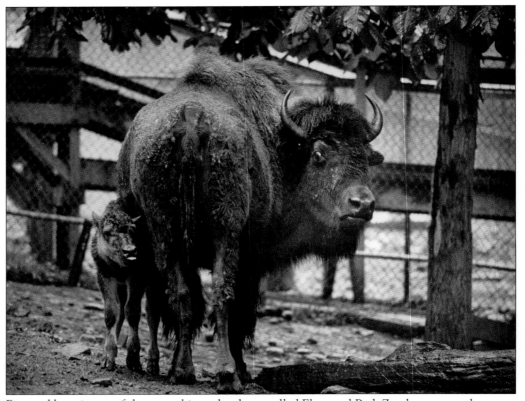

Pictured here is one of the many bison that have called Elmwood Park Zoo home over the years. Bison are members of the bovine family and spend their days roaming grasslands in search of food.

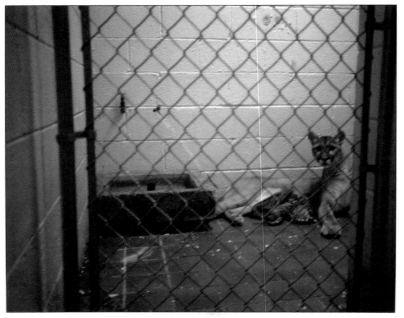

A cougar, native to North America, is seen here in an enclosure. The cougar, also known as the mountain lion, ranges from Canada to the southern Andes of South America.

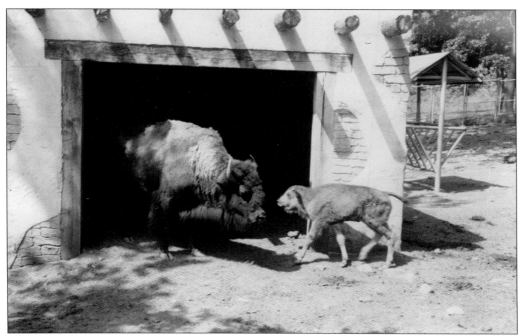

A bison takes a hard look at a young calf while standing in the door way to the bison house.

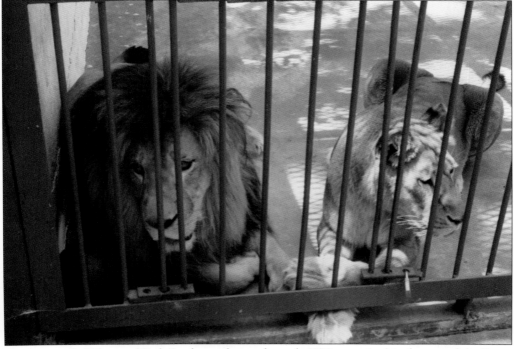

Two lions called Elmwood Park Zoo home during the early 1970s, seen in this photograph by Susan Owad. Residents could hear them roaring in the evening around dinnertime. The lioness once bit a man's finger, causing quite a stir in town. The bite became infected, and the man eventually had to have almost his entire arm amputated. (Courtesy of Susan Owad.)

Pictured here is an artist's rendering of the proposed new otter exhibit. Otters are one of the most watched animals at the zoo due to their constant motion when out and active.

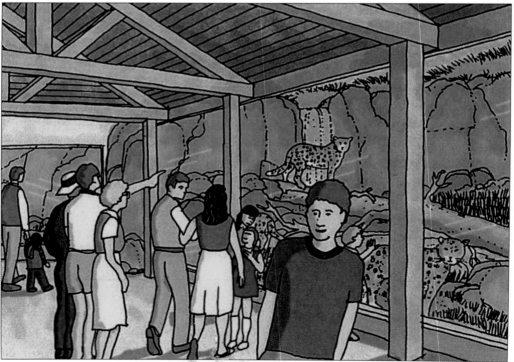

This artist's rendering shows the proposed new jaguar exhibit. The new glass enclosure will allow visitors an unobstructed view of the jaguars.

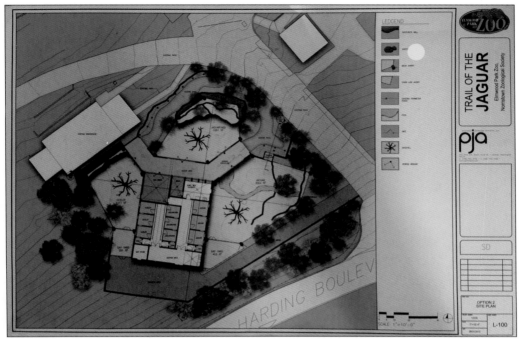

An architectural drawing depicts the proposed jaguar exhibit, where jaguarundis and ocelots will also be found.

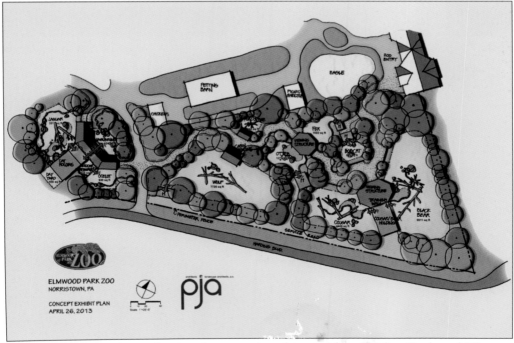

Here is an artist's rendering showing the revamping of the zoo along Harding Boulevard. The new jaguar exhibit is being made possible by a $3-million donation by a local philanthropist.

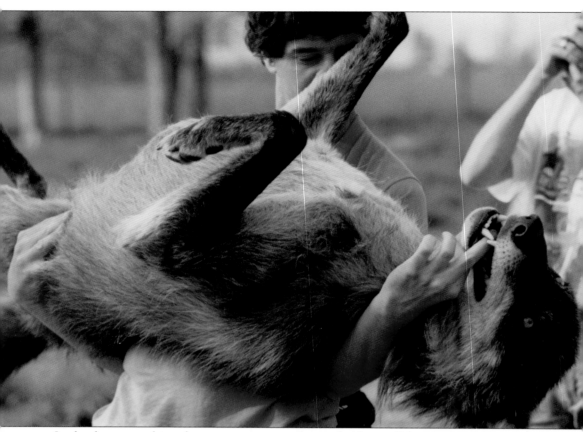

In the do-not-try-this-at-home category, a zoo keeper holds a wolf for visitors to examine a little more up close and personal than would normally be possible.

The bison building allows the large animals refuge from the weather, although they spend most of their time outside roaming their enclosure or simply relaxing in the shade.

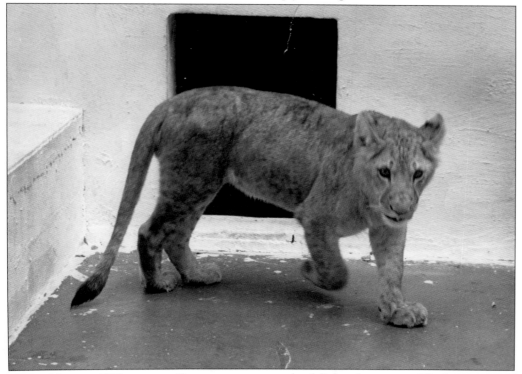

Pictured here in 1971, a young Caesar comes out to the delight of zoo-goers. The lion is one of two that once called the zoo home.

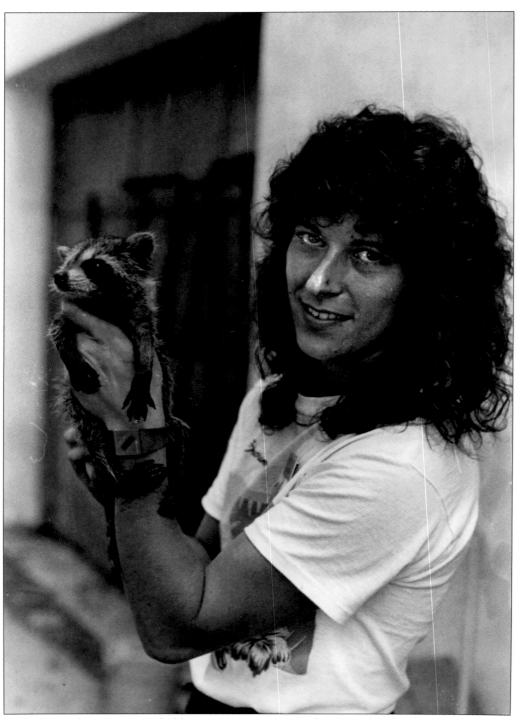

Zookeeper Valerie Cooper is holding a young raccoon in this 1987 photograph. The raccoon is native to North America and omnivorous as well as nocturnal. They are fairly small, ranging anywhere from eight to 20 pounds when full grown.

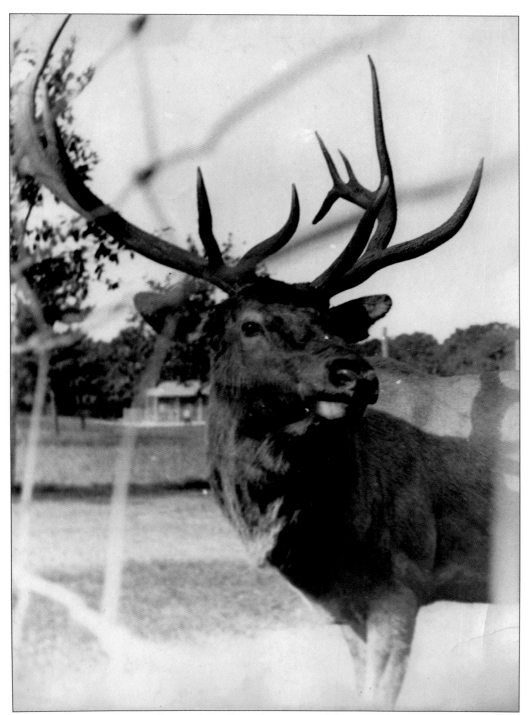

Elk have been mainstays at the zoo throughout the years, and this young buck is a prime specimen. Elk are members of the deer family and vegetarians, feeding mostly on grass, plants, leaves, and bark. The males shed their antlers each year.

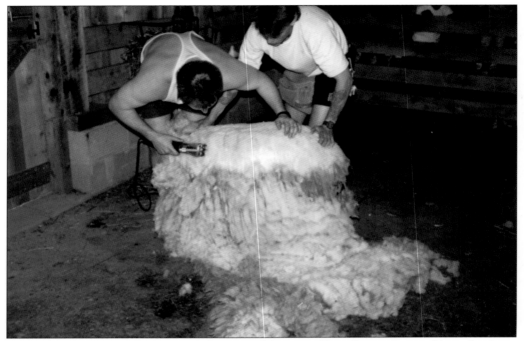

Sheep-shearing is part of a day's work for some of the animal handlers at the zoo. Typically, sheep are shorn once a year.

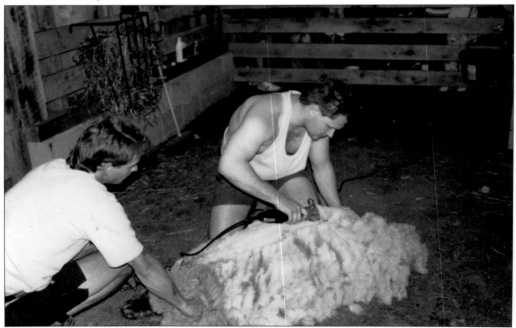

Shearers position the sheep on its side to make the work of shearing go a bit smoother. Animal keepers perform a multitude of tasks for all of the animals throughout the day and year. While there is not a particular season for shearing, it is usually done in the spring so the sheep will have a thick wool coat to wear through the winter months.

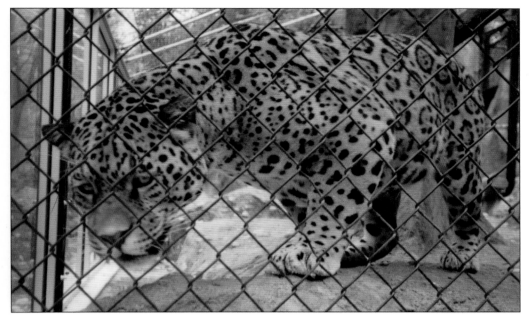

Anasazi, a young jaguar cub, pictured here in 1995, comes close to the fencing surrounding his enclosure. Jaguars have called the zoo home for many years. The jaguar is one of the only big cats native to North America. Its natural habitat extends from the southwestern portion of the United States down through Central America into Argentina.

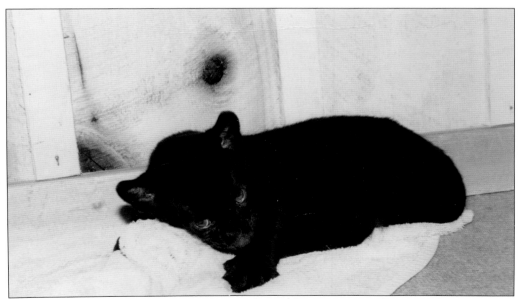

Cali, seen here at just 27 days old, was born on September 12, 1995. Cali was a melanistic jaguar. While a melanistic jaguar appears to be black, a closer examination will reveal its spots.

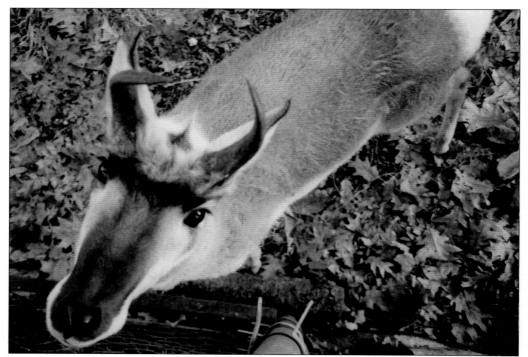

A pronghorn antelope is peering up at the camera in this 1996 photograph. Pronghorns are native to North America and have been members of the zoo for quite some time.

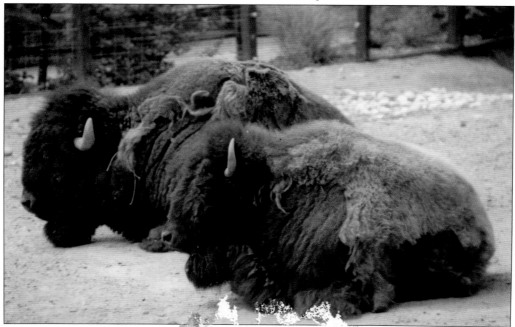

Pictured here is a pair of bison doi͏ ͏ ͏hat they do best. Bison also ͏ ͏ been members of the zoo for many years. Recently, a platform ͏as added near the exhibit so patrons can hand-feed the massive mammals, considered among the largest land dwellers native to North America.

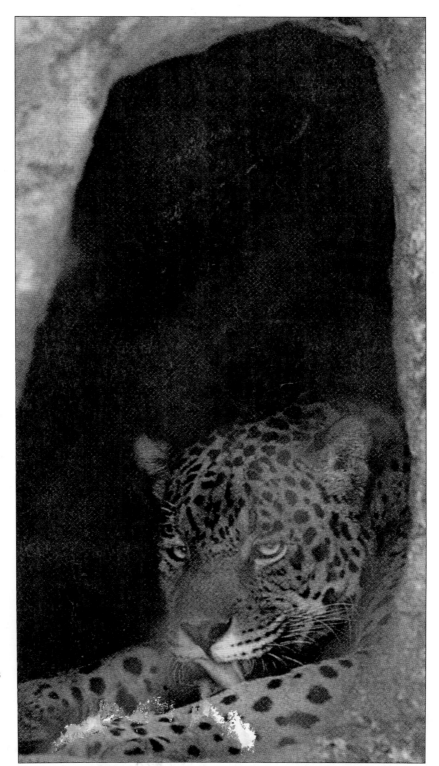

Anasazi, seen full grown here, peers out at patrons at the zoo in 2002, when he was seven years old. The big cats are often among the most watched animals at the zoo.

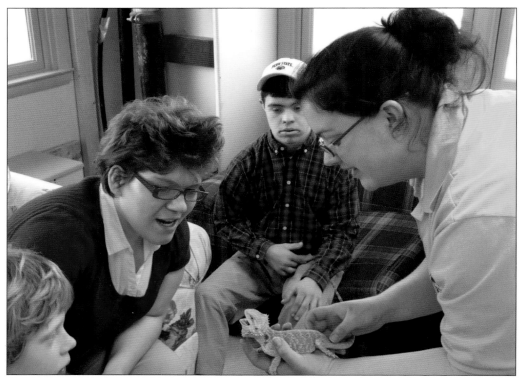

A zookeeper takes a young green iguana on a road trip in 2009. Education is always at the forefront at Elmwood Park Zoo, and the opportunity to teach youngsters about some of the more interesting, and portable, residents of the zoo is seldom missed. During the same outing in 2009, a Moluccan cockatoo is brought out for the children. The cockatoo is endangered in its natural habitat of Indonesia and is a protected species.

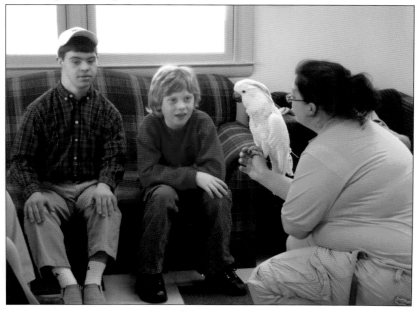

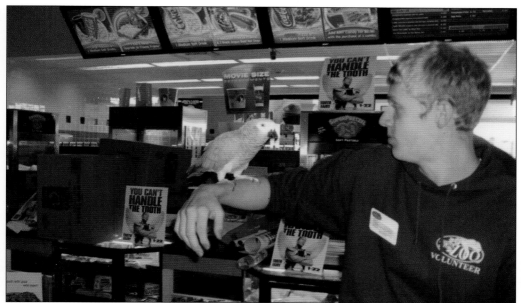

During another outing, an African grey parrot, seen here with a volunteer in 2010, allows passersby an opportunity to see the exotic bird up close.

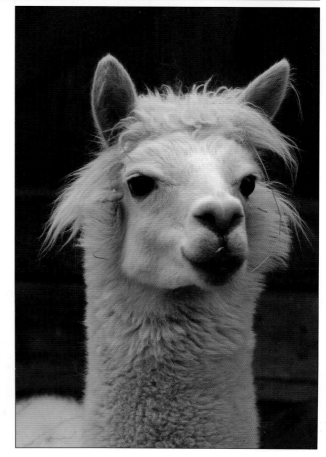

The zoo was home to an alpaca in 2010. The alpaca is native to South America and is a domesticated animal. They are shorn each year just as sheep are, and the wool is used to make a variety of garments.

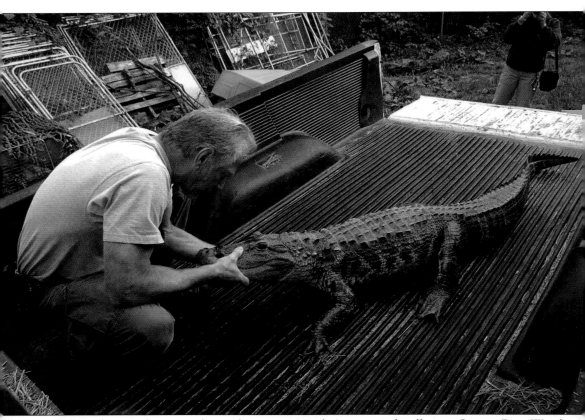

Perhaps the most fearsome of animals native to North America is the alligator. Curator Dave Wood is taking care with this young, yet still extremely powerful, member of the alligator family.

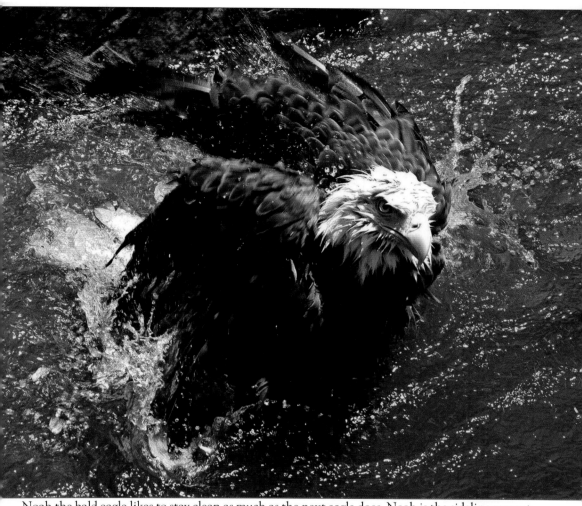

Noah the bald eagle likes to stay clean as much as the next eagle does. Noah is the sideline mascot for the Philadelphia Eagles, so he has to look good for the camera.

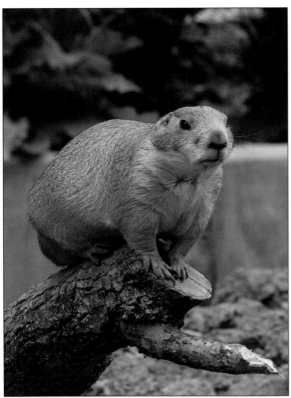

One of the first open exhibits at the zoo was the prairie dog habitat. Prairie Dog Village was constructed in 1979 in an ongoing effort to allow visitors to see the animals in their natural habitats.

Two residents of Prairie Dog Village come out to say hello to visitors. The open exhibit allows visitors the opportunity to see the animals in what more closely represents their natural habitat.

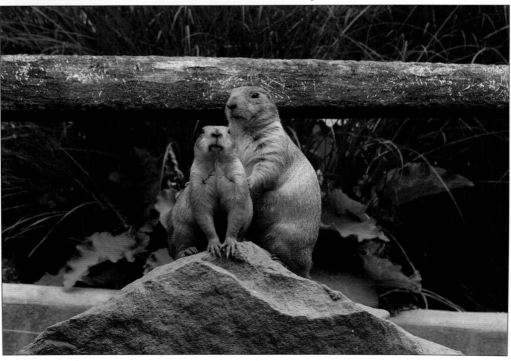

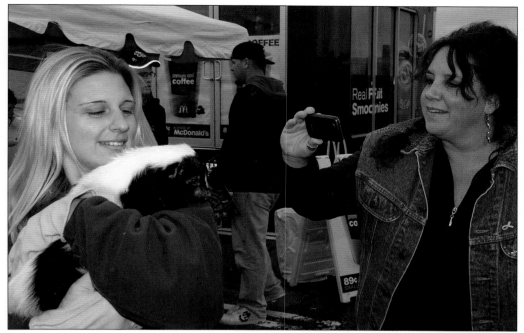

An animal handler seems right at home with a skunk, who came out to lend a helping hand with the Camp Out for Hunger event held in 2010.

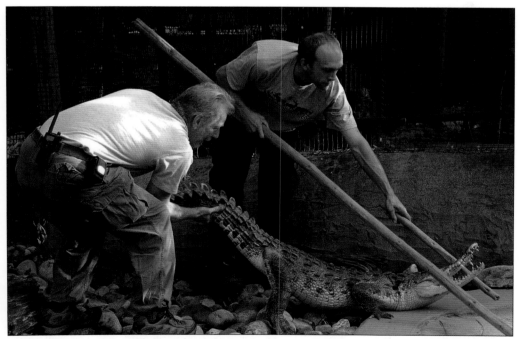

Zoo curator Dave Wood (left) and another animal keeper at the zoo guide an American alligator back into its habitat. Every precaution is taken with the large reptiles, which are native to North America.

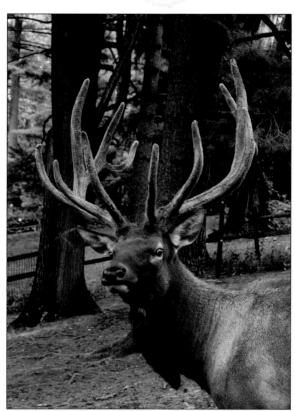

An elk with a full rack peers out at visitors in 2010. Elk have been one of the longest-standing members of the zoo collection. Mollie, at 26 years old in 1977, was considered the oldest living elk in captivity in America.

A baby cougar is seen in this undated photograph. Cougars, or mountain lions as they are also known, are the second-largest feline native to the Americas next to the jaguar.

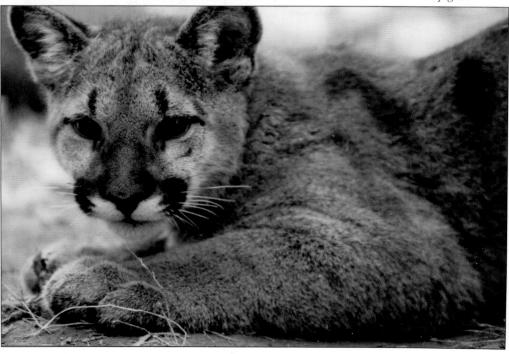

EPILOGUE

Plans for expanding the zoo fly fast and furious through executive director Albert Zone's mind. There is the new cougar exhibit, which is being made possible by a $3-million donation by a local philanthropist.

Next on the agenda, the zoo has teamed up with some amazing donors, both corporate and individual, and foundations to build an amazing future for the zoo. Zone speaks eagerly about the future:

"We're already thinking about our 100th anniversary. We're bringing in some amazing architects and builders to bring Montgomery County a Disney-like facility. We're hiring companies like PJA and Work As Play, original designers of Disney's Animal Kingdom, to bring Elmwood the trail of the majestic predator. We're talking about North America's largest cat, the jaguar. Along with the jaguar we will be adding ocelots and jaguarondis. The jaguar exhibit will have underwater viewing. That exhibit is fully funded and will open in the near future," he continues. "We'll continue that momentum. We want to tell stories. We want to give a take away message to our visitors. We're going to do new exhibits for the cougar, grizzly bears, river otters, bobcats, all focusing on our North American animals. My vision is to give a better way to educate, to make it more interactive and educational by way of entertainment. Getting the information off of the signs and actually having the exhibits tell a story, to give a message that will last."

The interview with Zone does not last long and it is a frenetic one at that. When talking about plans for the new exhibit, Zone jumps from his office chair and goes into another office and asks to have the plans sent to him electronically.

Zoo curator Dave Wood stops by with Rae Mendez from Work As Play to talk about a couple of the new exhibits. Mendez is on the board at Disney's Animal Kingdom, which he also helped design.

Before long, Zone bolts from his chair on his way to the kitchen at the zoo. He has a group of realtors hosting an event, and he wants to make sure everything is running smoothly.

His attention to detail and flair for showmanship have not increased visitors to the zoo, but membership has skyrocketed, going from a modest 1,600 members when he arrived to more than 36,000 in 2015.

"There are millions of animal collection facilities across the world, but only 228 AZA facilities in the United States and we're proud to be one of them," Zone concludes seriously. "We can make an impact at this level. It changes the future for a lot of the animals that are on the verge of extinction, and allows us to educate the consumer on the importance of the Association of Zoos and Aquariums."

DISCOVER THOUSANDS OF LOCAL HISTORY BOOKS FEATURING MILLIONS OF VINTAGE IMAGES

Arcadia Publishing, the leading local history publisher in the United States, is committed to making history accessible and meaningful through publishing books that celebrate and preserve the heritage of America's people and places.

Find more books like this at
www.arcadiapublishing.com

Search for your hometown history, your old stomping grounds, and even your favorite sports team.

Consistent with our mission to preserve history on a local level, this book was printed in South Carolina on American-made paper and manufactured entirely in the United States. Products carrying the accredited Forest Stewardship Council (FSC) label are printed on 100 percent FSC-certified paper.

MADE IN THE USA